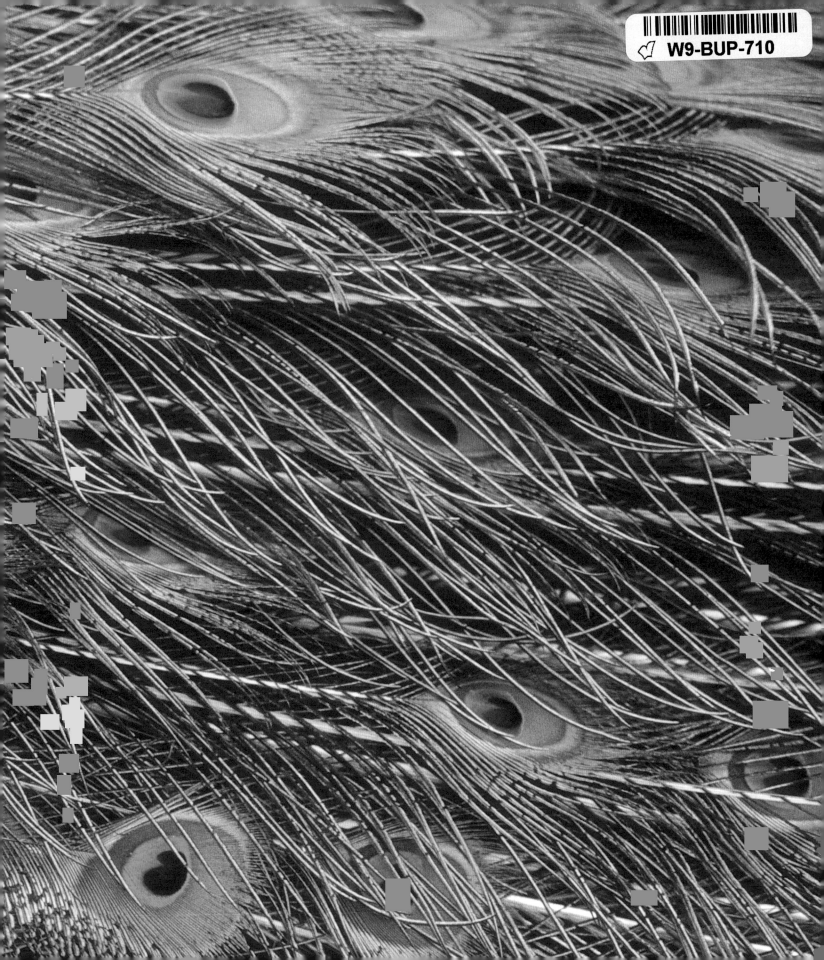

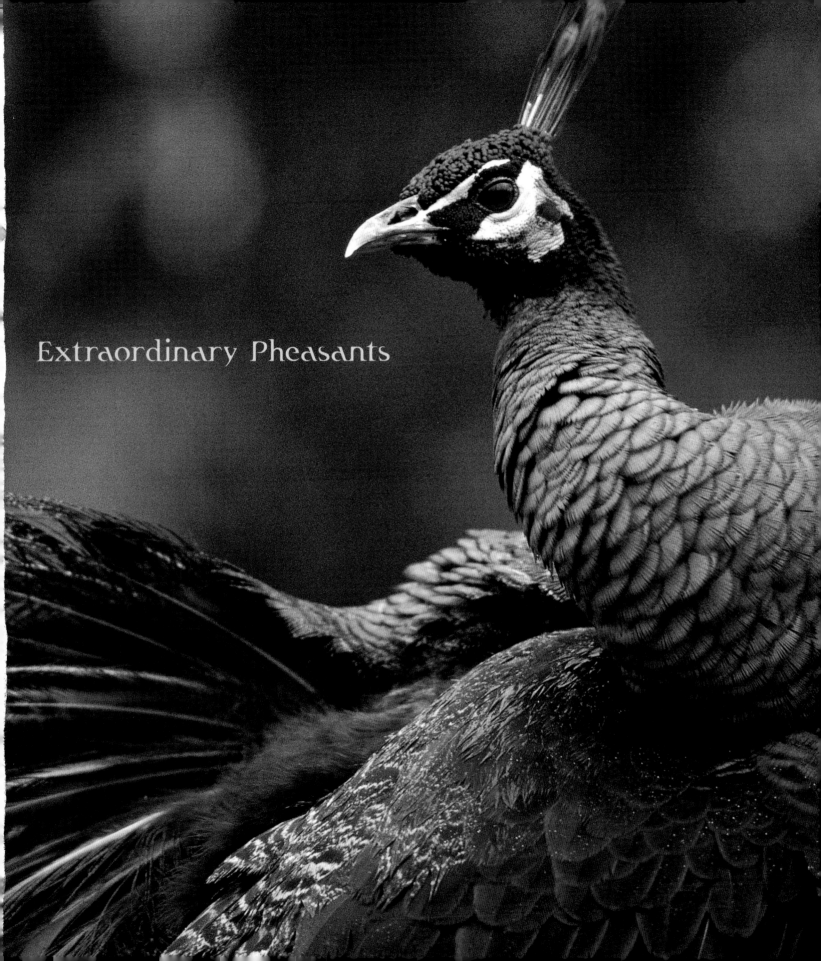

Extraordinary Pheasants

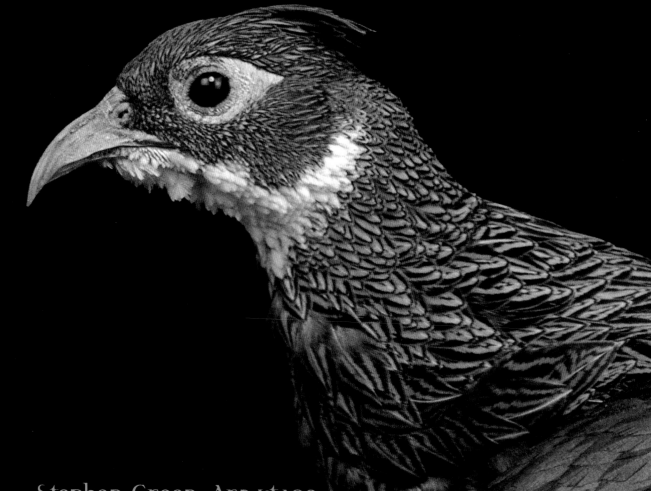

Stephen Green-Armytage

Extraordinary
Pheasants

HARRY N. ABRAMS, INC., PUBLISHERS

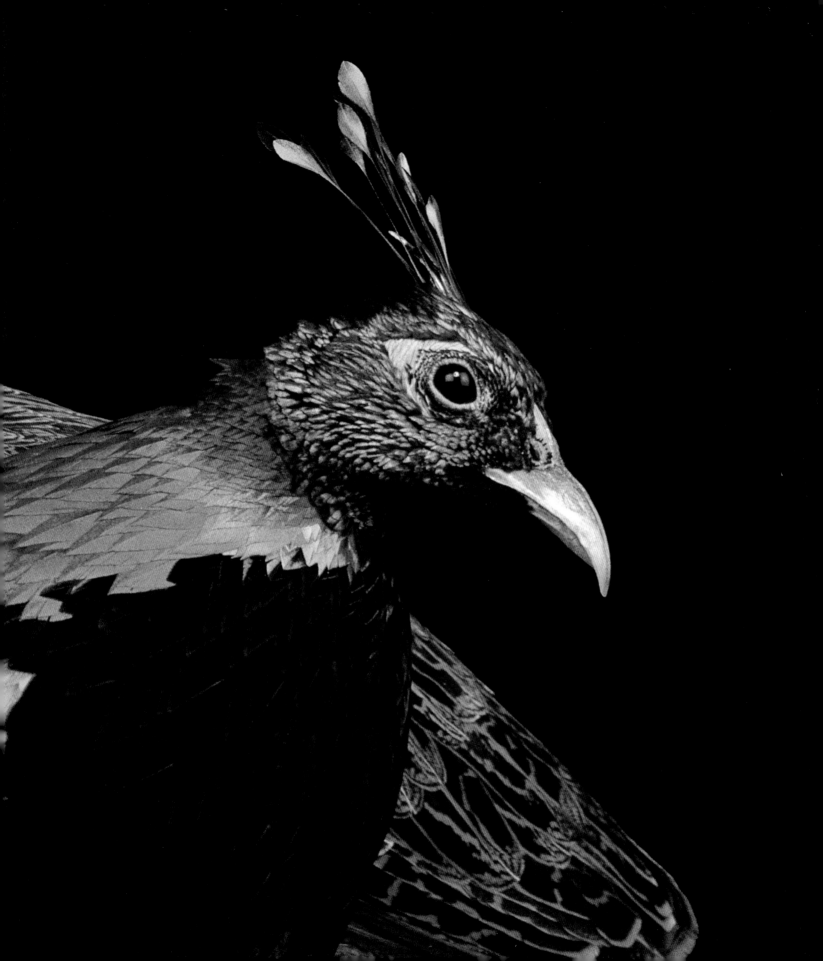

Contents

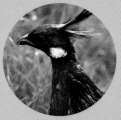

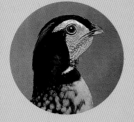
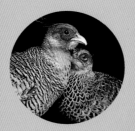
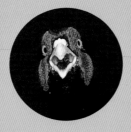
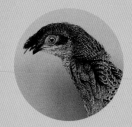
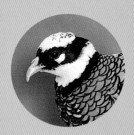
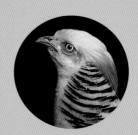

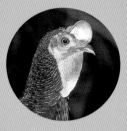
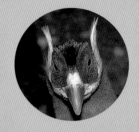

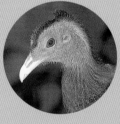
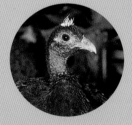
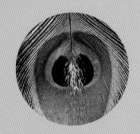

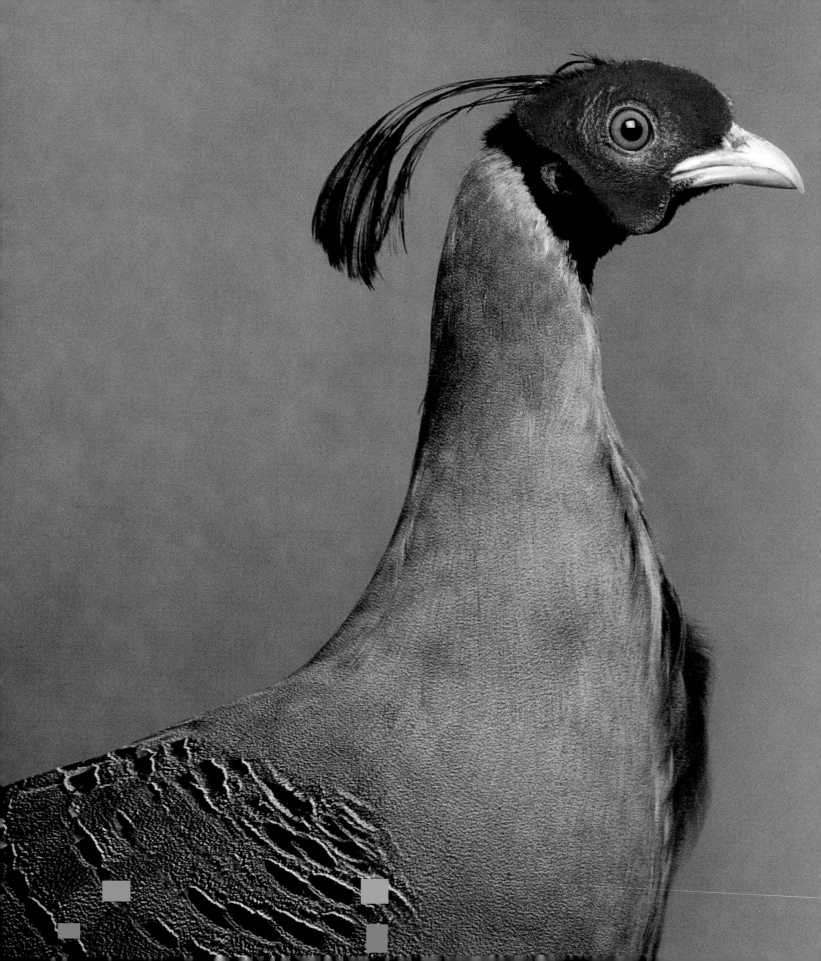

Preface

It would be hard to find a group of birds with so many assets among them as those displayed by the pheasant family. Perhaps their most obvious shared asset is good looks. The Common, or Ring-necked Pheasant, which can be seen in the woods and farmlands of many countries, is always an impressive sight—a large, beautifully balanced bird with feathers that are bright and colorful but in perfect harmony with the landscape, featuring subtle patterns and a rich sheen. Yet this is only one species among dozens of gorgeous birds of many different shapes, sizes, and colors, ranging from vivid blues, greens, and purples to velvet blacks, soft grays, and clean whites, not to mention the astonishingly brilliant displays of the peacocks—yes, these exotic birds are also pheasants. Although the Indian Blue peacock may be universally known, many people do not know that peafowl are now bred in many colors, including green, white, bronze, emerald, and purple.

In addition to peafowl, the reader will meet a handful of birds called Peacock Pheasants, which are about the size of a chicken and mostly covered in blue spots, as well as the Himalayan Monal, the Bornean Fireback, the Great Argus, and the Lady Amherst's Pheasant. One will also see images of the Koklass, Tragopans, Jungle Fowl, Zarudny's Pheasant from the Caucasus, and many more. Readers are also introduced to the unique and bizarre Congo Peacock, a species discovered only recently in the deep forests of Central Africa, far away from its Asian counterparts. Perhaps some members of the parrot family have more brilliant colors and some hummingbirds have more iridescent feathers, but neither bird can match the variety of shapes, colors, and patterns of those you will see in the following pages.

As was true with my earlier volume, *Extraordinary Chickens,* I am aiming neither for an encyclopedic treatment nor an identification guide, but for a pictorial celebration of these wonderful and surprising birds. In contrast to the thoroughly domesticated chicken, however, pheasants are wild animals. Unfortunately, of the nearly two hundred pheasant species, subspecies, and mutations, many are rare and endangered, having been hunted in their native habitats for their meat and for their beautiful feathers. They have also suffered widespread habitat loss as expanding human populations in Asia, their primary home, have reduced their territories. One bird that is almost extinct in the wild, the Edward's Pheasant, had the misfortune to be native to Vietnam. Happily, many of these extraordinary species are being preserved through breeding programs in zoos, aviaries, and private collections, and it was from these sources that I was able to take my subjects.

There are many fine collections of pheasants in Europe and elsewhere, and breeders have been preserving and propagating them successfully for decades. However, for logistical reasons,

OPPOSITE PAGE:
Siamese Fireback

ABOVE:
Silver Pied Peacock

OVERLEAF:
Ghigi Pheasant

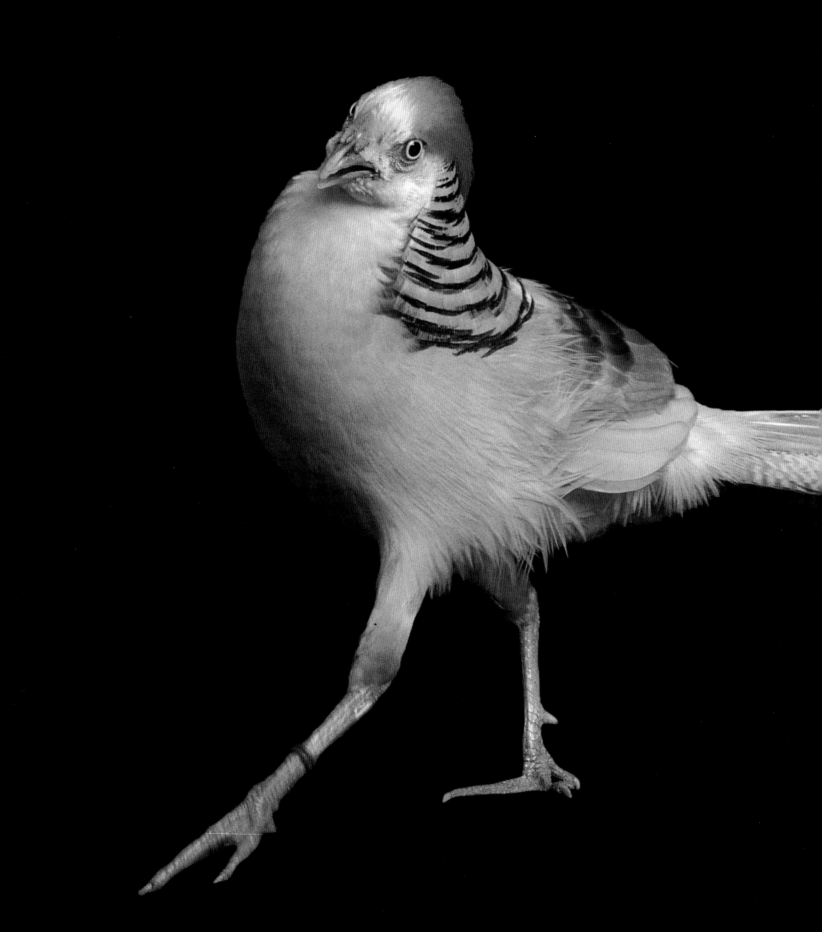

I restricted my photography to the United States. Even in that one country, however, I traveled many thousands of miles by plane and by car to be able to include a wide variety of species. Only three public collections were visited, and the majority of my work was done at the private aviaries of some of the hundreds of breeders who are helping to preserve rare pheasants. This book would not have been possible without their generous help.

When photographing pheasants, I often chose to give them an uncluttered background by using plain fabrics or studio background paper. Sometimes this was not practical, and in certain aviaries the presence of a good natural background gave the illusion that the birds were in the wild. My presence as a stranger was liable to make some birds anxious for a while, and it inhibited many males from the mating displays that are witnessed by owners and by more regular visitors. Fortunately, most peacocks were not shy or reserved.

Pheasants probably exhibit greater difference between the sexes than any other group of birds. The peafowl is an extreme example of sexual dimorphism, with the peacocks being spectacularly colorful and the peahens mostly very plain. I have more often photographed the males, aware that a book predominantly on pheasant hens would be visually disappointing. You can be sure, however, that hens don't envy the colorful male plumage when they are sitting on their nests. Almost all pheasants nest on the ground, and a look at some of the hens in this book will show how well camouflaged they are. The cock birds are of course able to present themselves as glamorous mates when seeking the attention of females, but their bright colors make them more conspicuous to predators, both animal and human.

At the end of the book, I will list the people who have helped me, particularly those breeders and collectors who allowed me to photograph their specimens. Some were very protective of the privacy of their pheasants, giving them good cover in which to hide and seldom entering their pens, subscribing to the theory that more fertile eggs would be laid by birds whose lives were as close as possible to being natural. The experience of observing the birds and their habits thus seemed similiar to that of a biologist or bird-watcher. In other cases, the pheasants had become accustomed to humans in their enclosures and had learned that visitors were not dangerous.

Sometimes the birds themselves could potentially be dangerous—a few males have been known to use their spurs to attack people. I was never harmed, though there were times when birds were flying close to me and I followed advice by putting my arms in front of my face. Occasionally I came across pheasants that were like "trusties," moving freely around the aviaries, often curious about human activities, rather like pets. Peafowl in particular often roamed free outside their pens and were large enough to deter potential predators.

Most aviculturists, those who breed pheasants, waterfowl, doves, and ornamental chickens, welcomed the prospect of this publication. They hope that increased awareness of the beauty of pheasants will increase knowledge of their merits and their endangered status, thus encouraging more people to become involved in their preservation. It is also hoped that all bird lovers will appreciate the book, and that indeed anyone who admires beautiful and interesting animals will enjoy the photographs and will want to learn more about these fascinating creatures.

ABOVE:
Blyth's Tragopan

OPPOSITE:
Green Jungle Fowl

OVERLEAF:
Buford Bronze Peacock

10

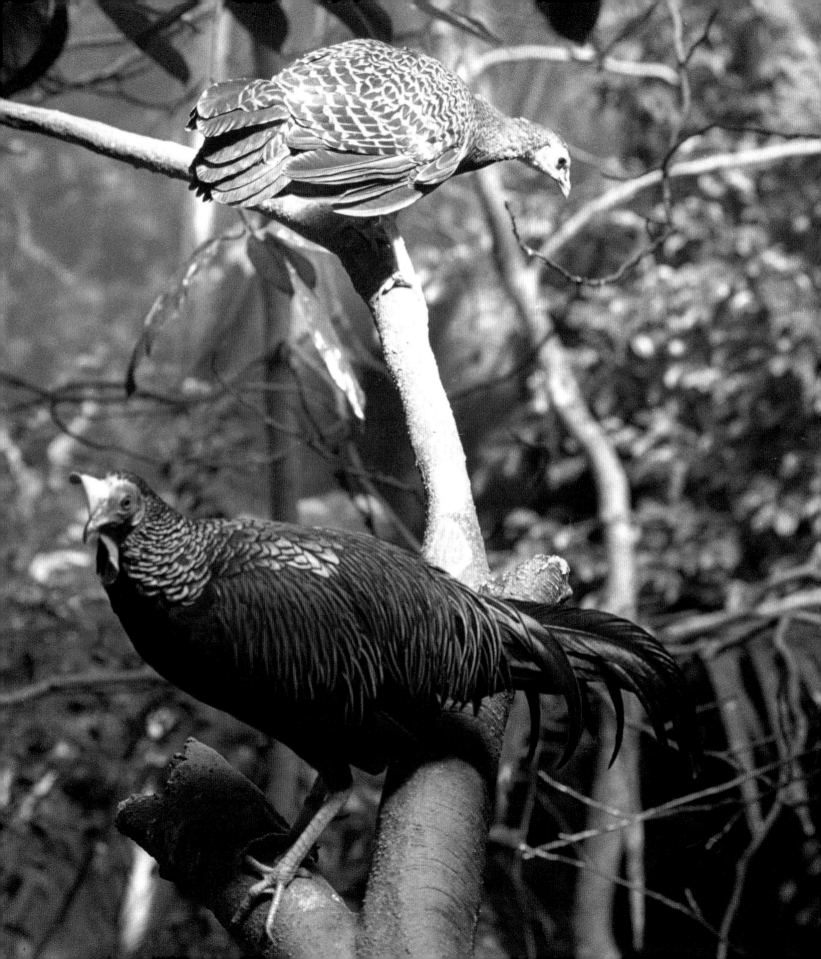

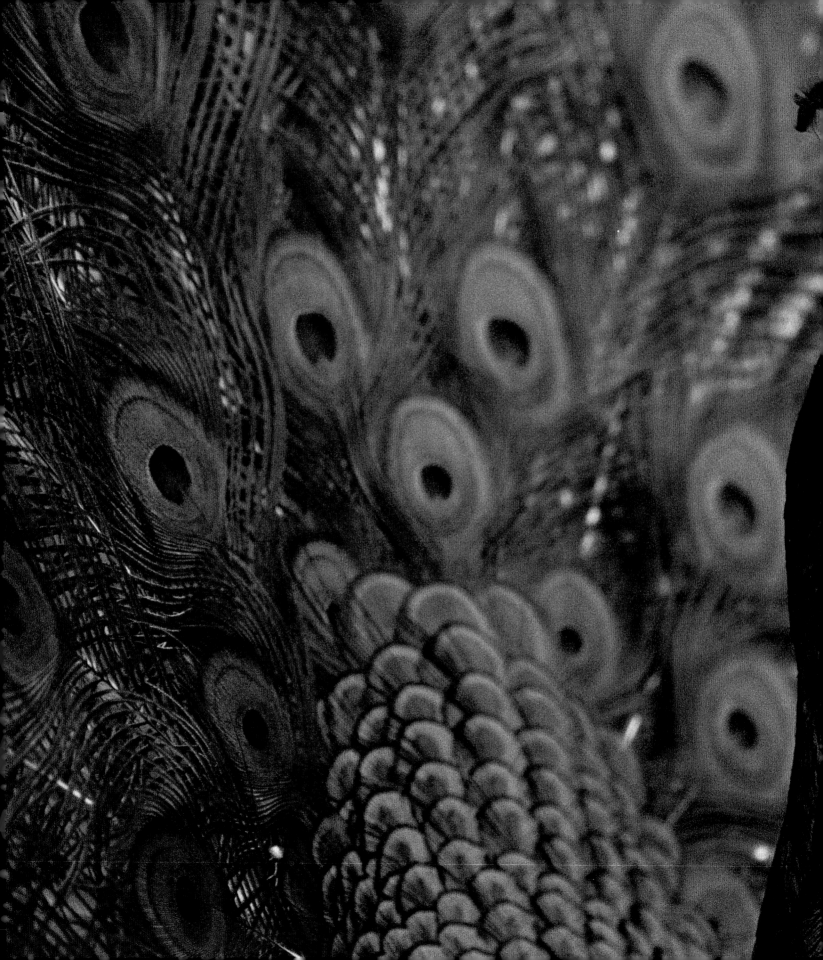

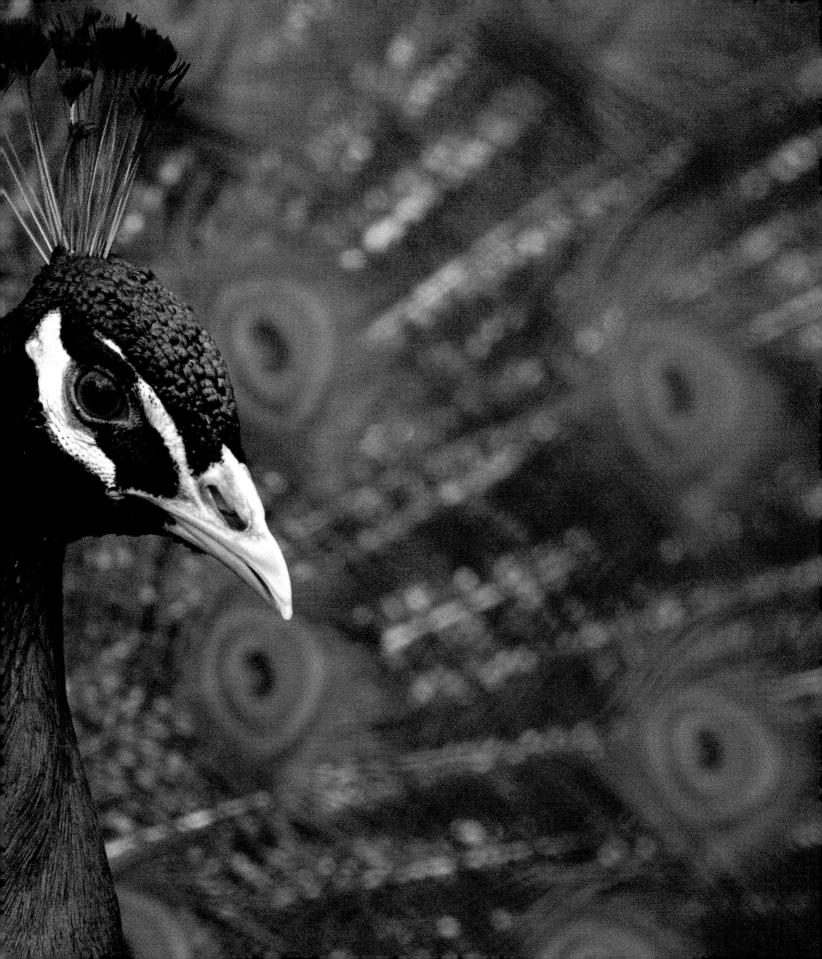

Tragopans

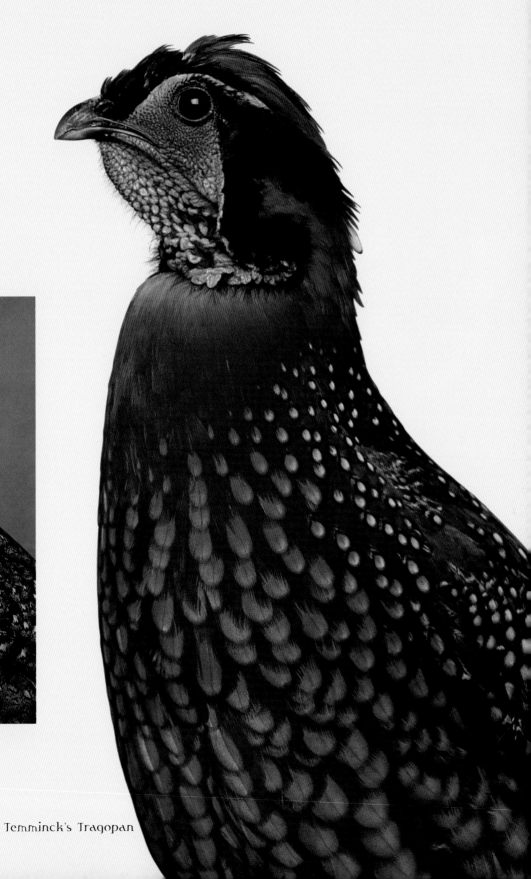

Temminck's Tragopan Hen

Temminck's Tragopan

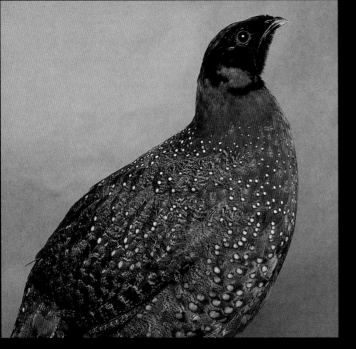

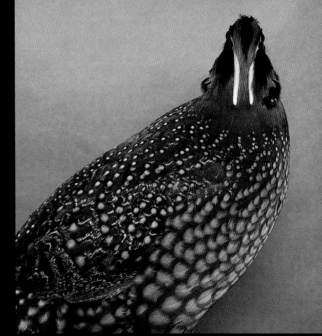

Satyr Tragopan

Temminck's Tragopan

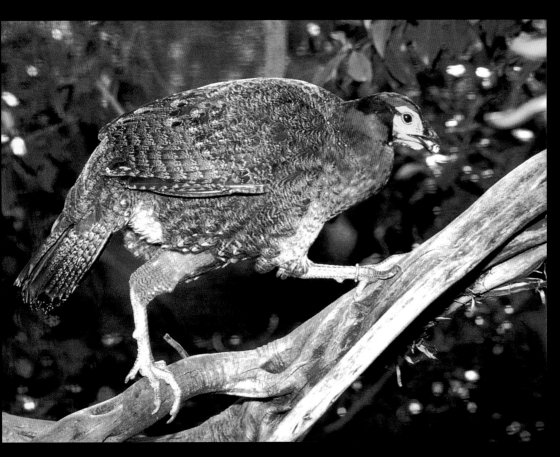

Blyth's Tragopan—Juvenile

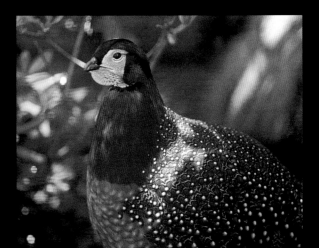

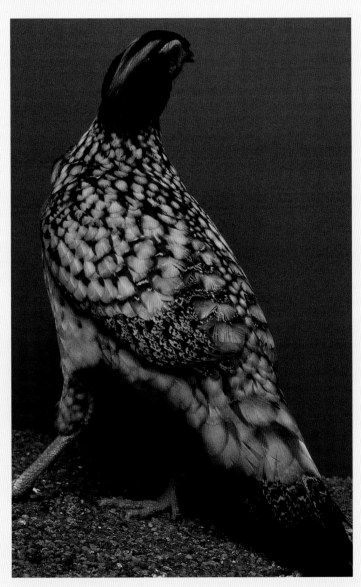

Cabot's Tragopan

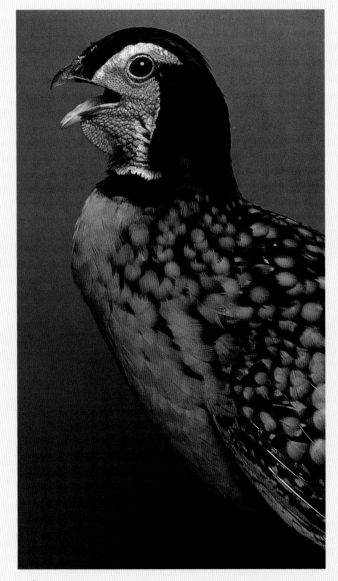

Cabot's Tragopan

Koklass

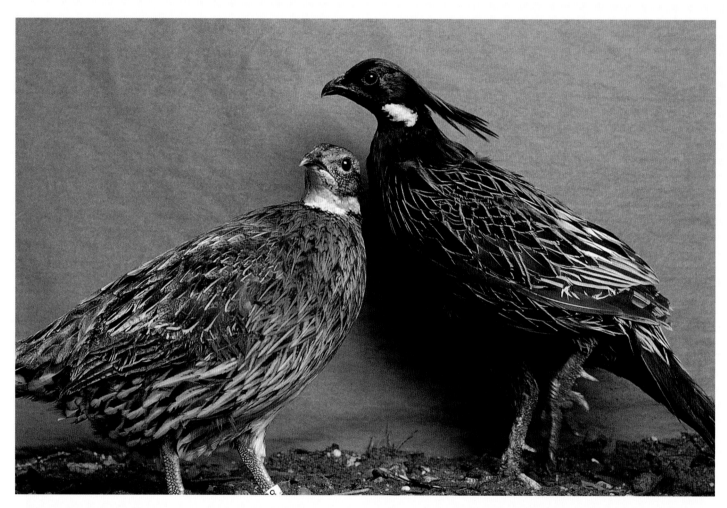

Koklass Pheasant—Pair

Cheer

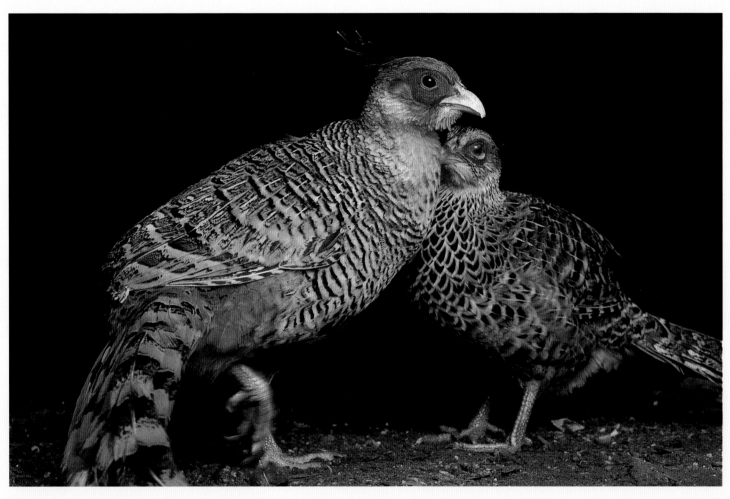

Cheer Pheasant—Pair

Monals

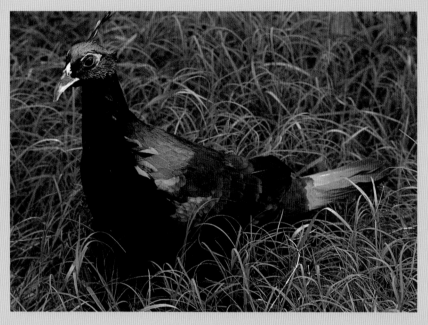

Impeyan

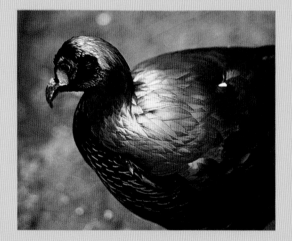

Chinese Monal

Chinese Monal

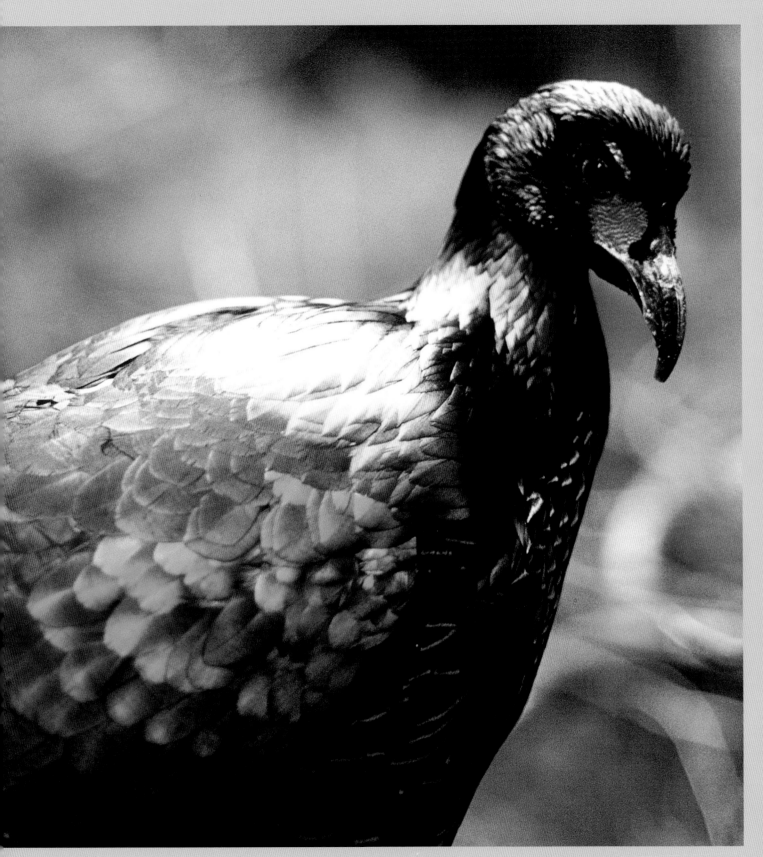

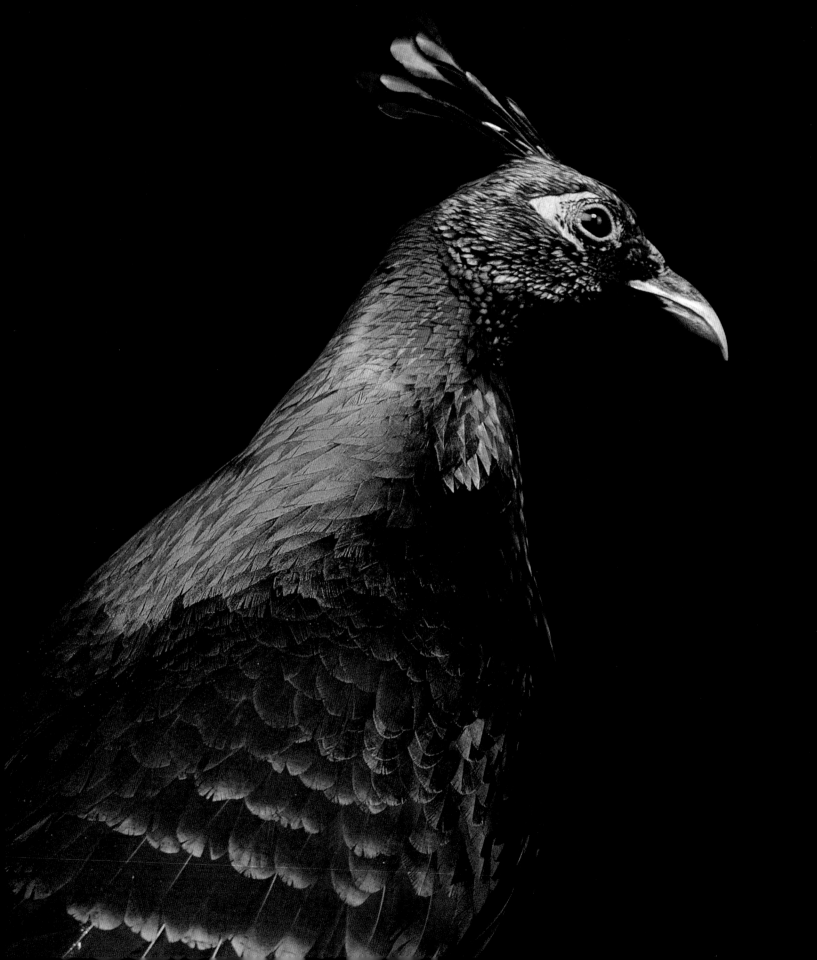

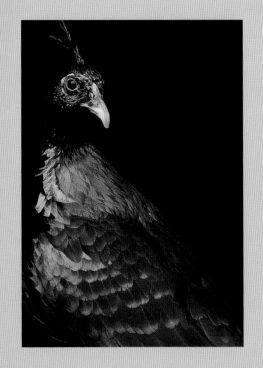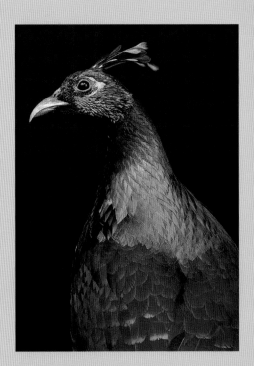

Impeyan

Jungle Fowl

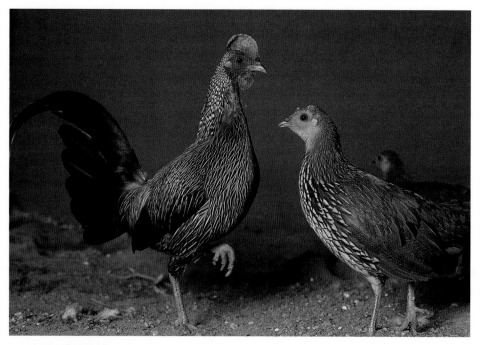

Grey Jungle Fowl

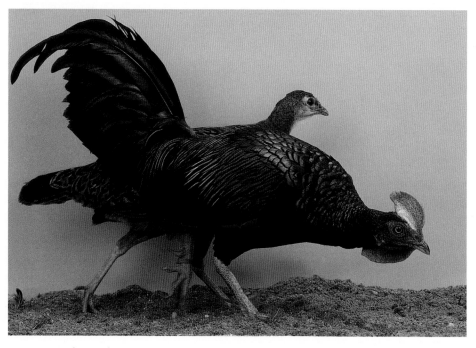

Green Jungle Fowl

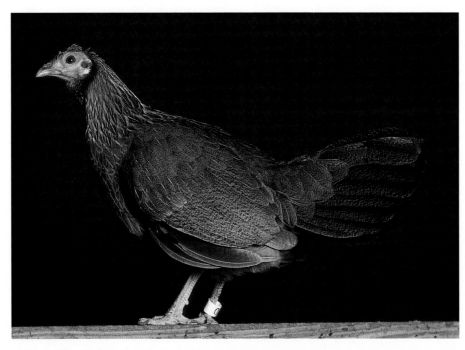

Red Jungle Fowl Hen

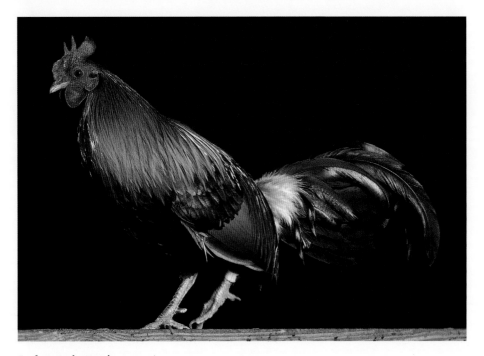

Red Jungle Fowl

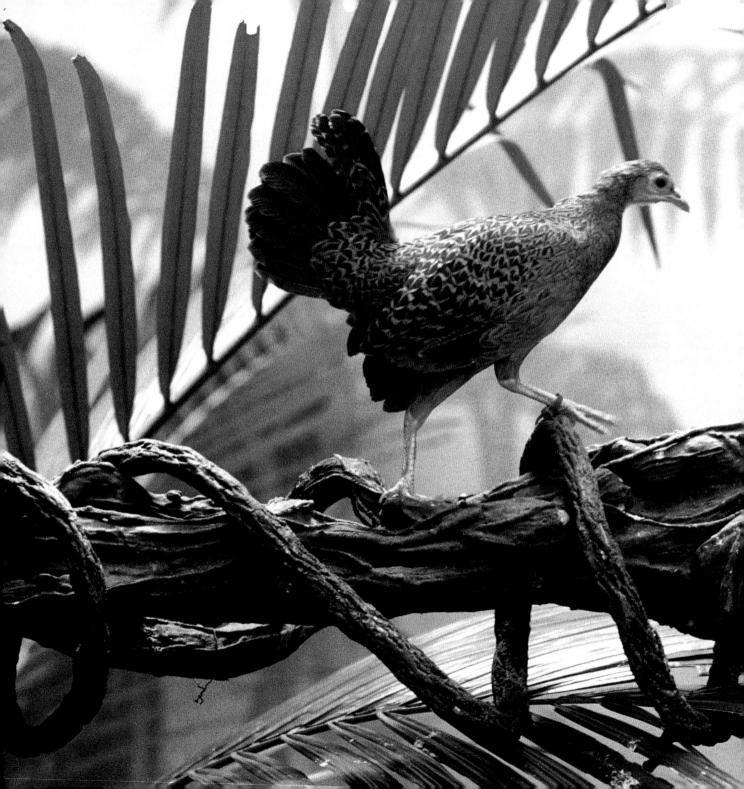

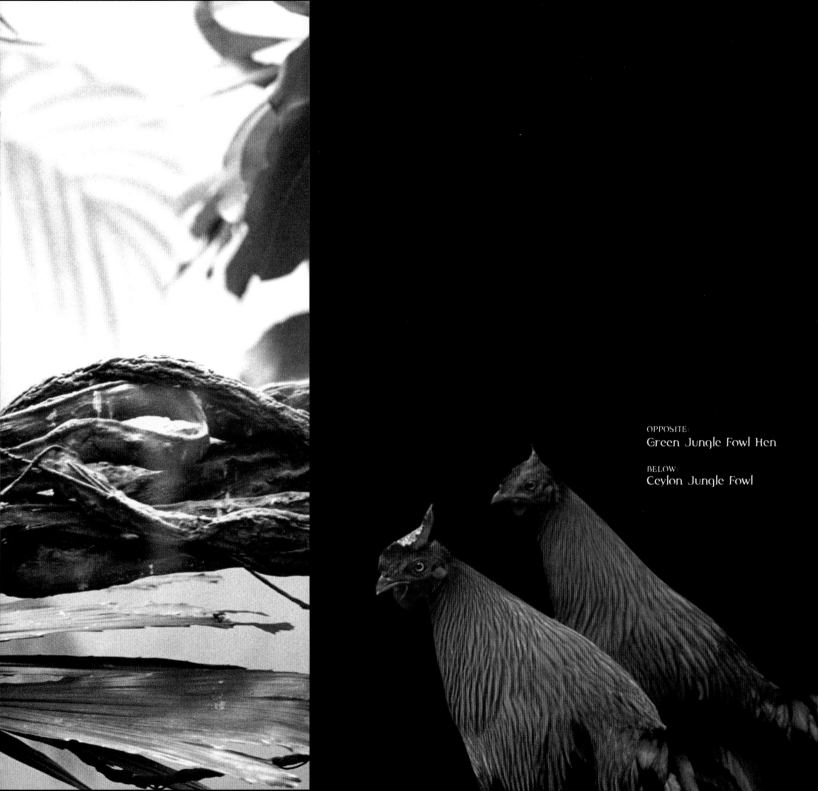

OPPOSITE:
Green Jungle Fowl Hen

BELOW:
Ceylon Jungle Fowl

Eared Pheasants

ABOVE:
Brown Eared Pheasant

OPPOSITE:
White Eared Pheasant

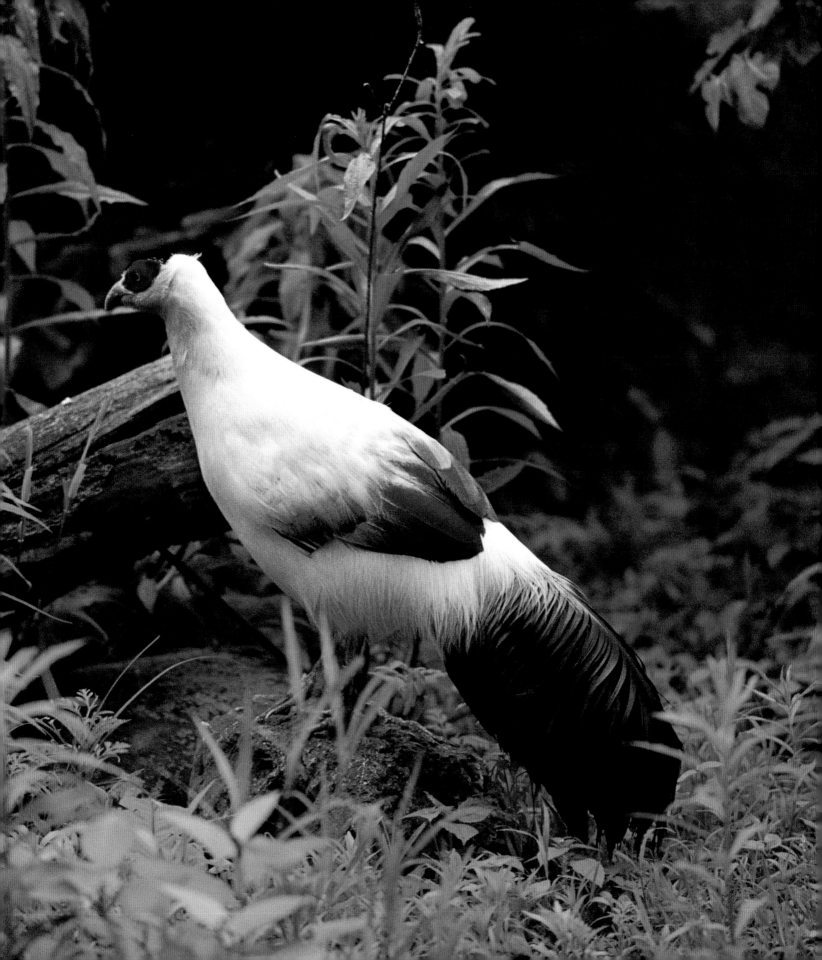

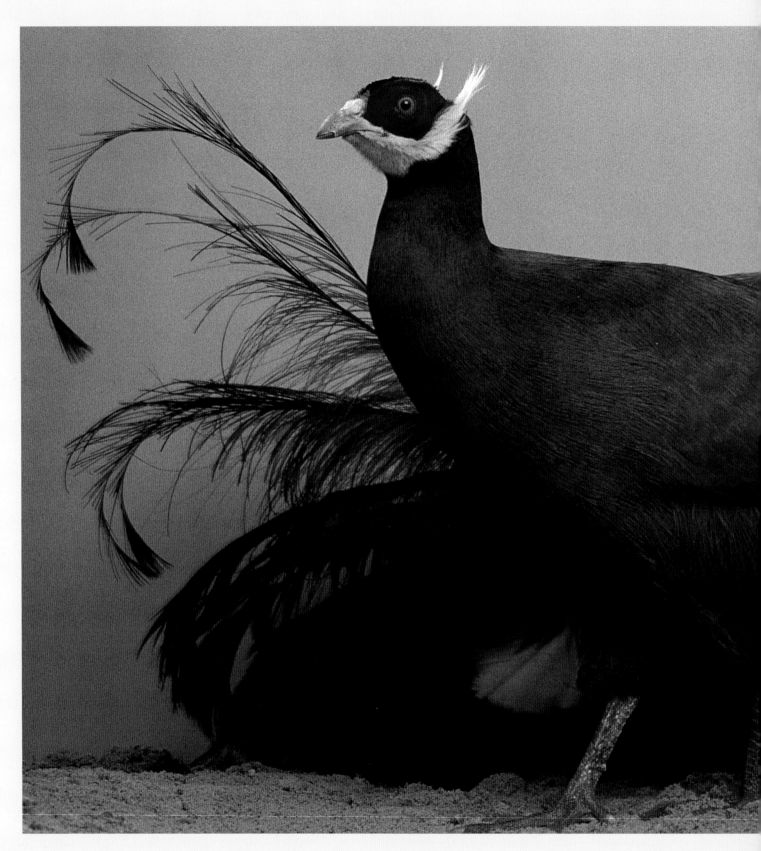

Blue Eared Pheasant—Pair (Hen at rear)

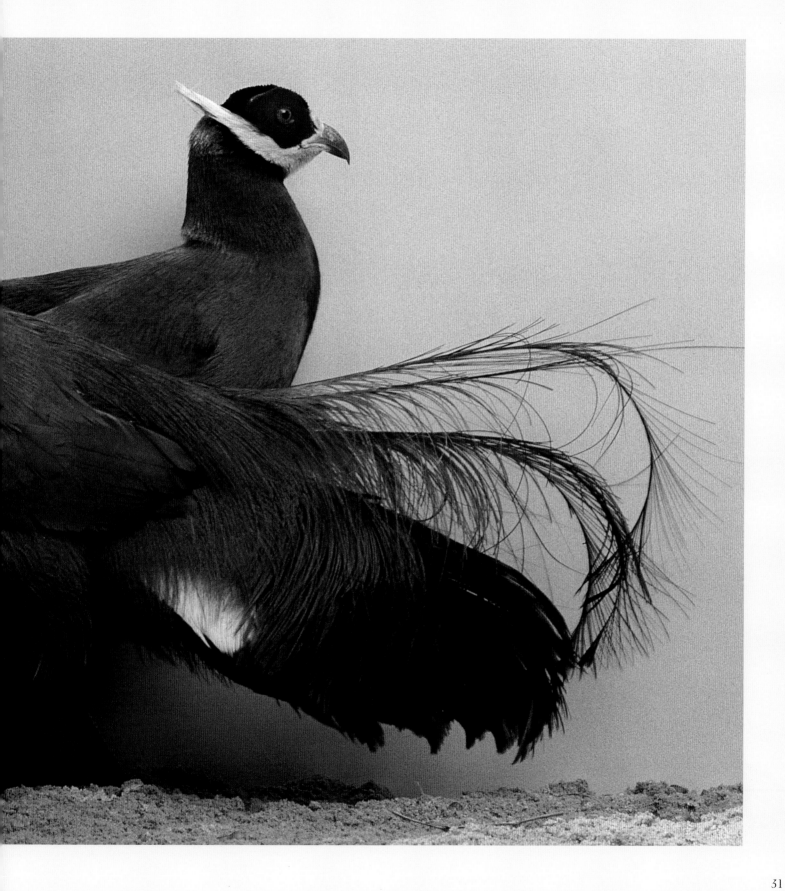

Gallopheasants

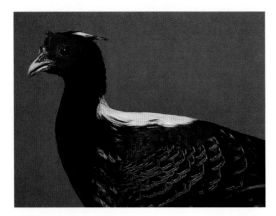

Swinhoe's Pheasant

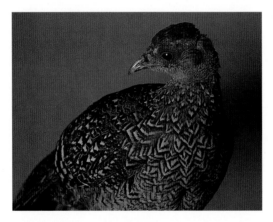

Swinhoe's Pheasant Hen

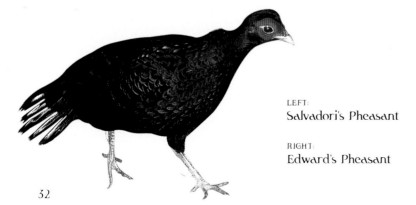

LEFT:
Salvadori's Pheasant

RIGHT:
Edward's Pheasant

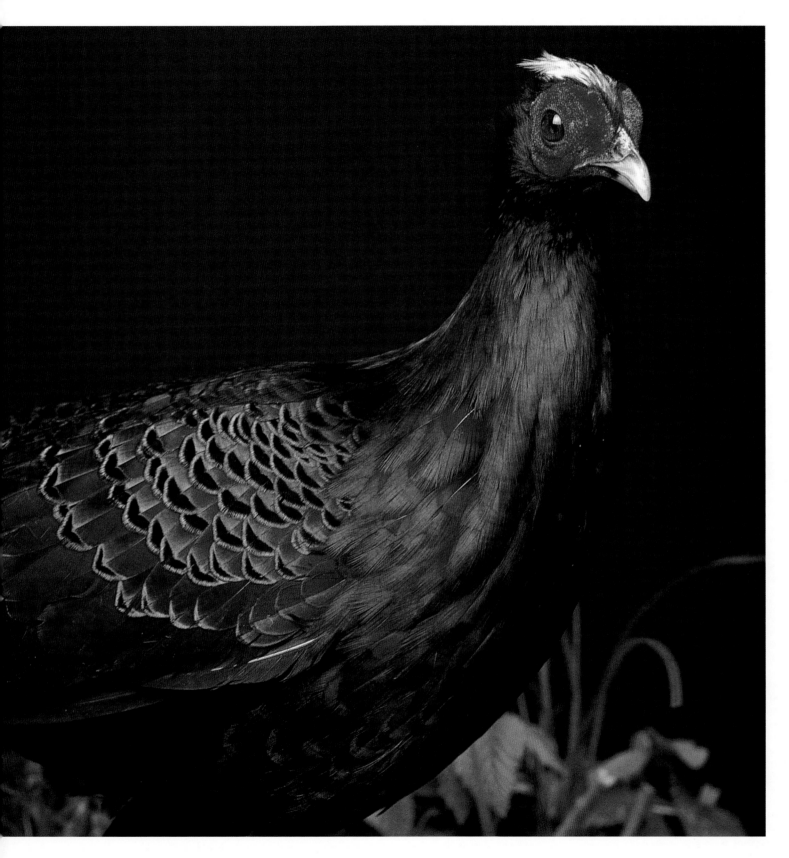

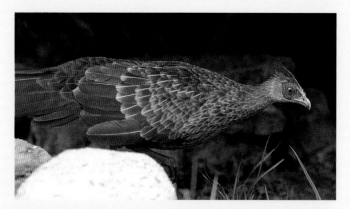

Lewis's Silver Pheasant Hen

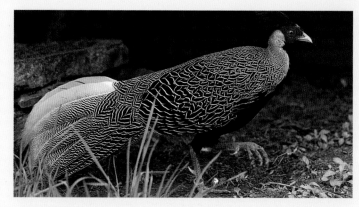

Lewis's Silver Pheasant

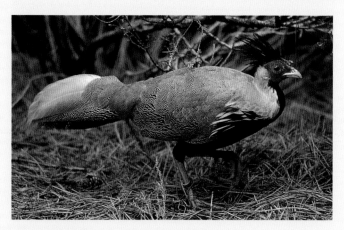

Lineated Kalij

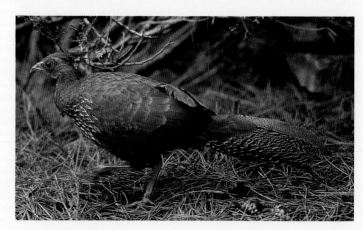

Lineated Kalij Hen

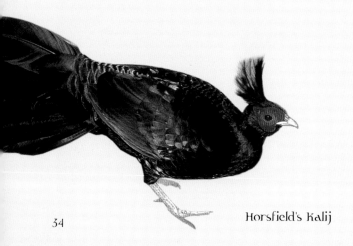

34

Horsfield's Kalij

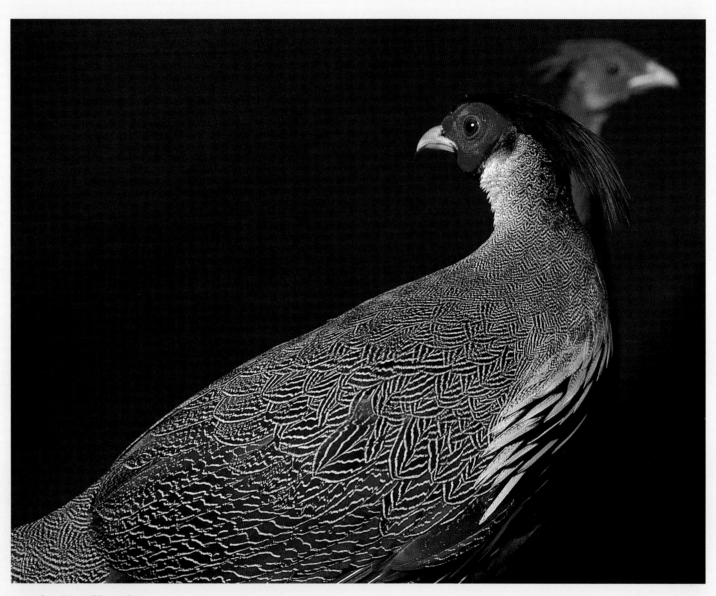

Crawfurd's Kalij—Pair

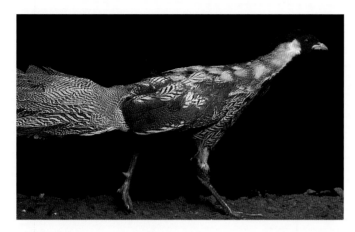

Silver Pheasant—Juvenile

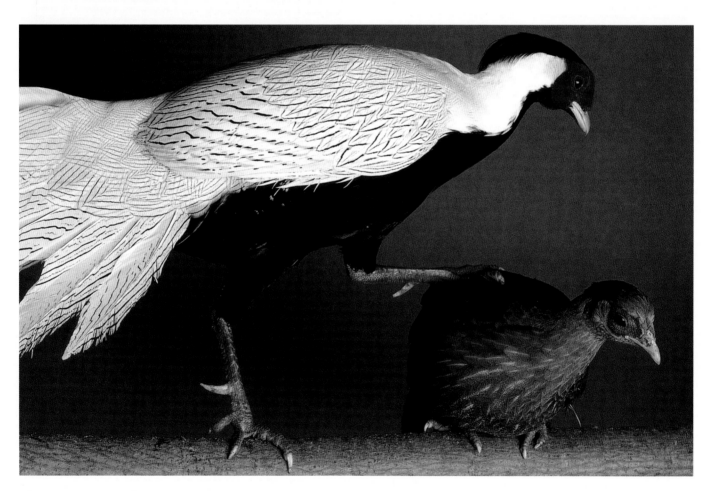

Silver Pheasant—Pair

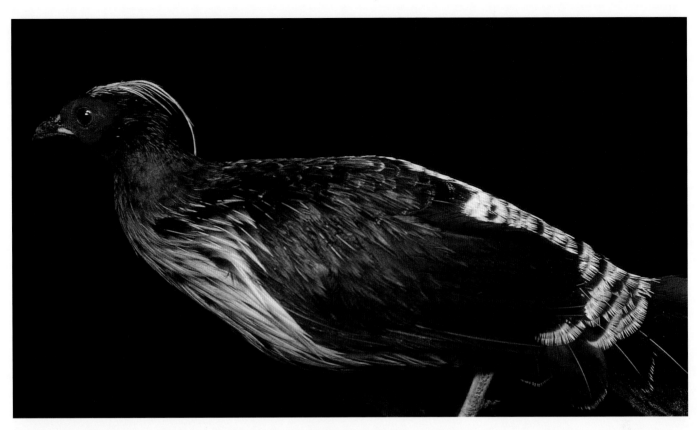

White-Crested Kalij

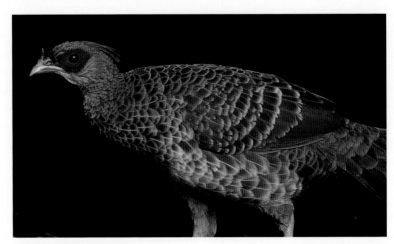

White-Crested Kalij Hen

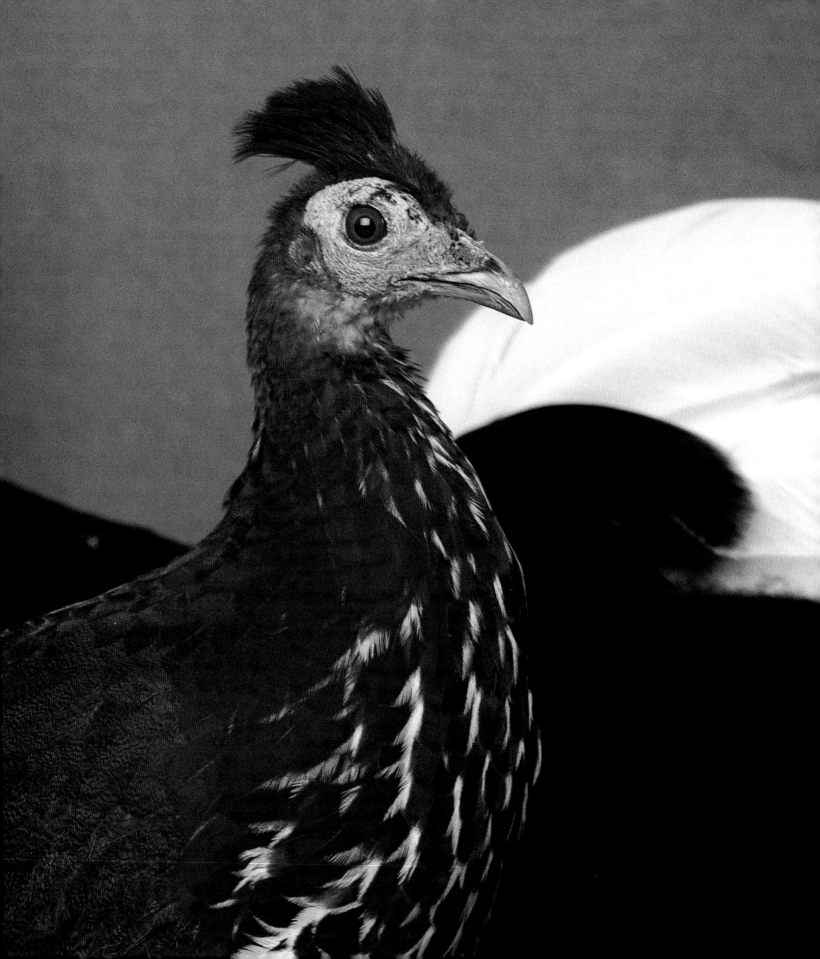

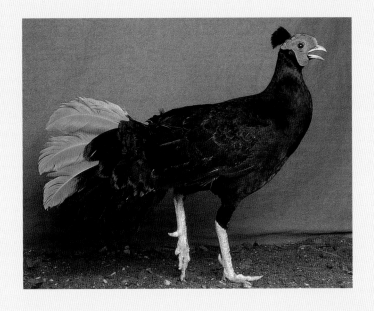

LEFT:
Bornean Crested Fireback

BELOW:
Malay Crested Fireback

OPPOSITE PAGE:
Malay Crested Fireback Hen

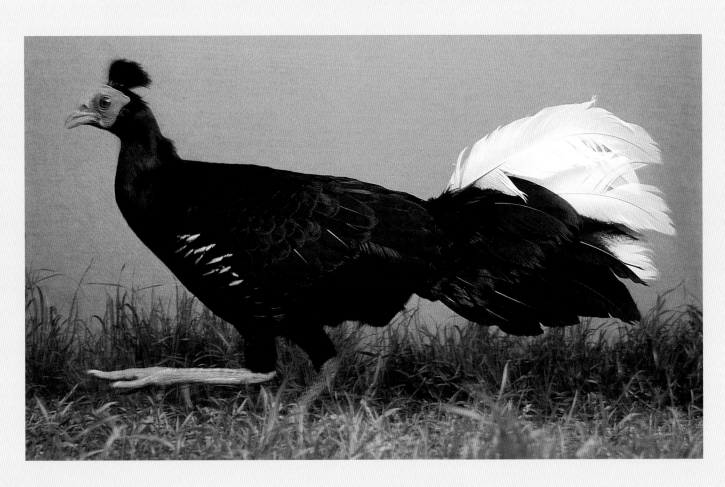

RIGHT:
Delacour's Fireback

BELOW:
Siamese Fireback

OPPOSITE:
Malay Crestless Fireback

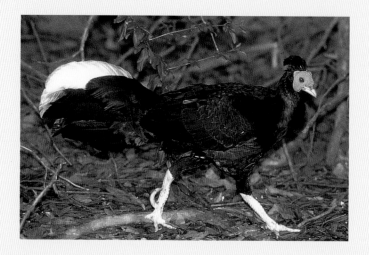

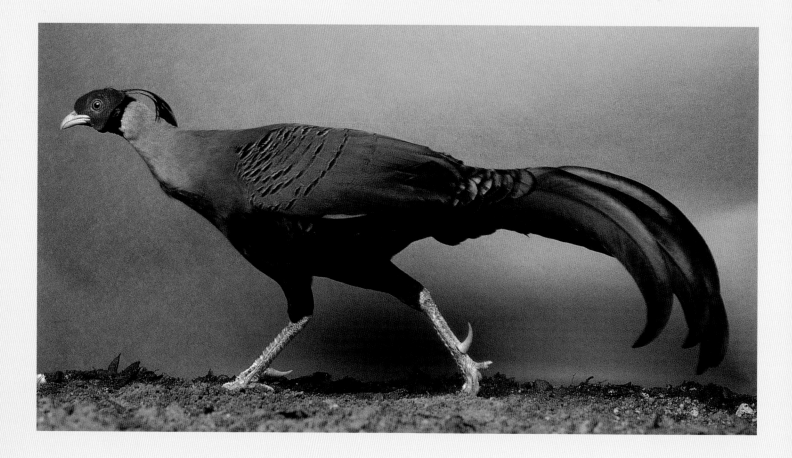

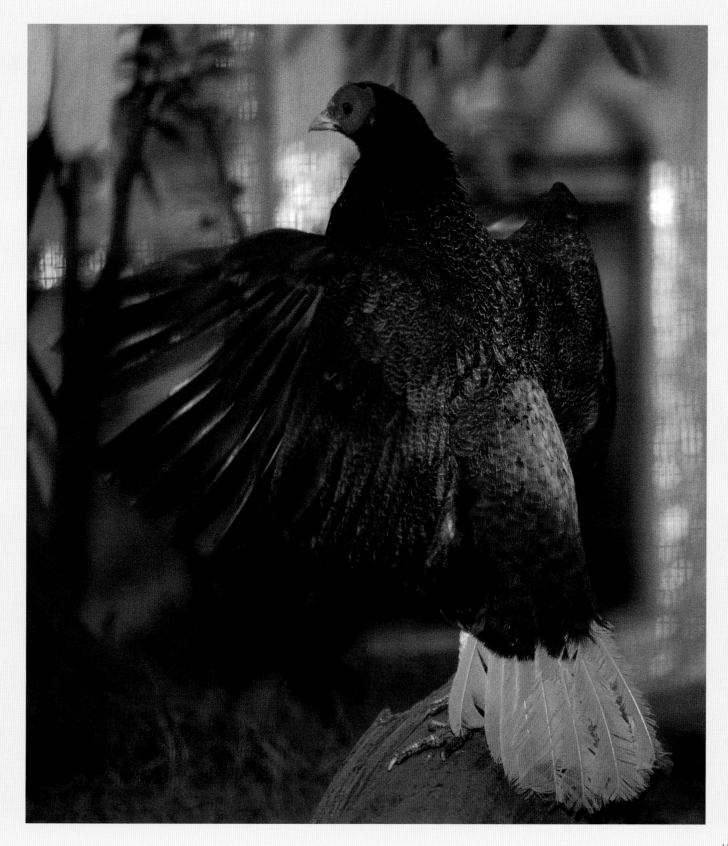

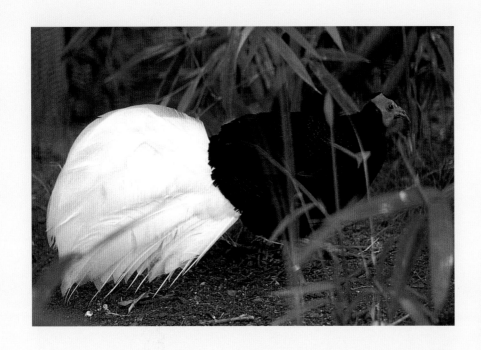

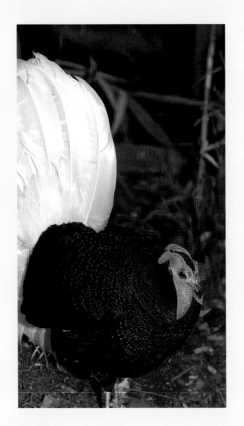

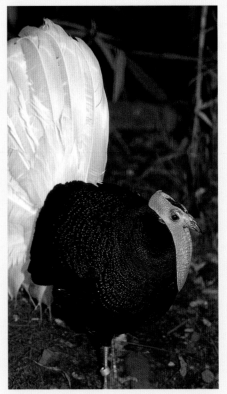

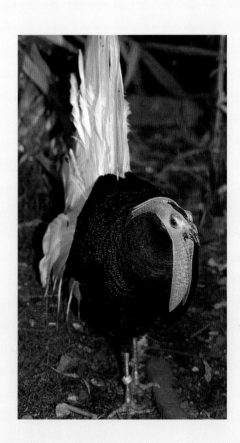

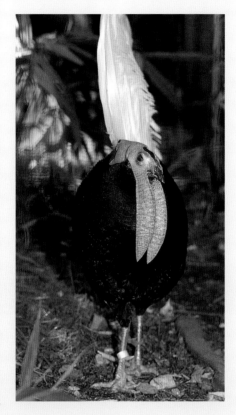

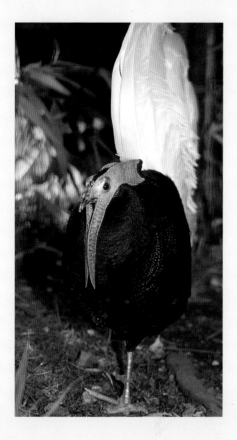

Bulwer's Pheasant—Displaying

43

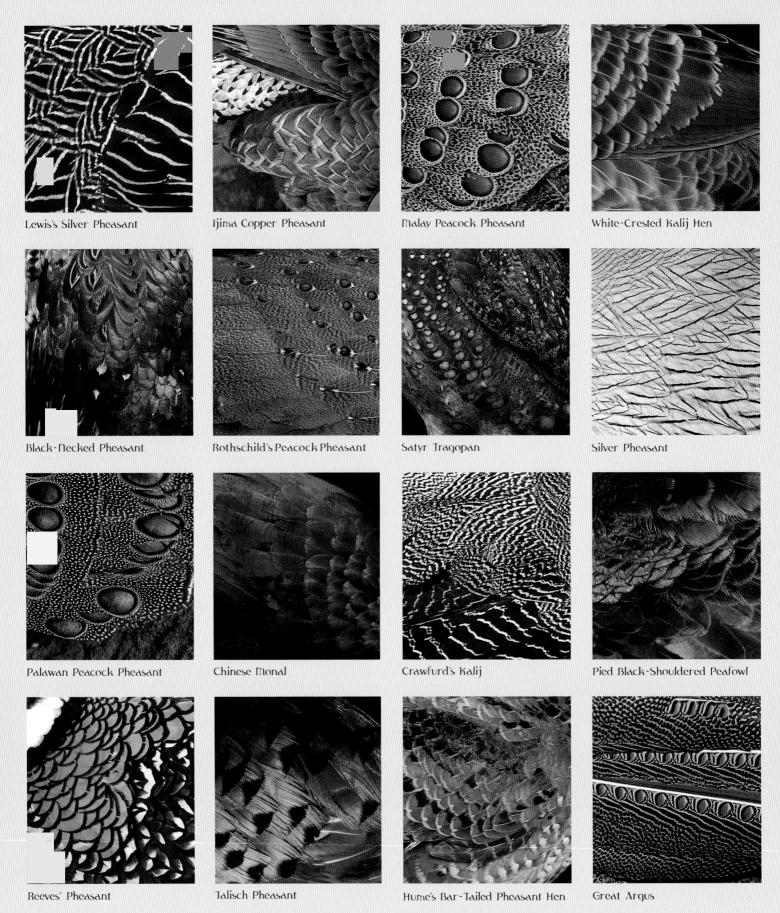

Lewis's Silver Pheasant

Ijima Copper Pheasant

Malay Peacock Pheasant

White-Crested Kalij Hen

Black-Necked Pheasant

Rothschild's Peacock Pheasant

Satyr Tragopan

Silver Pheasant

Palawan Peacock Pheasant

Chinese Monal

Crawfurd's Kalij

Pied Black-Shouldered Peafowl

Reeves' Pheasant

Talisch Pheasant

Hume's Bar-Tailed Pheasant Hen

Great Argus

OPPOSITE Green Pheasant—Feather detail

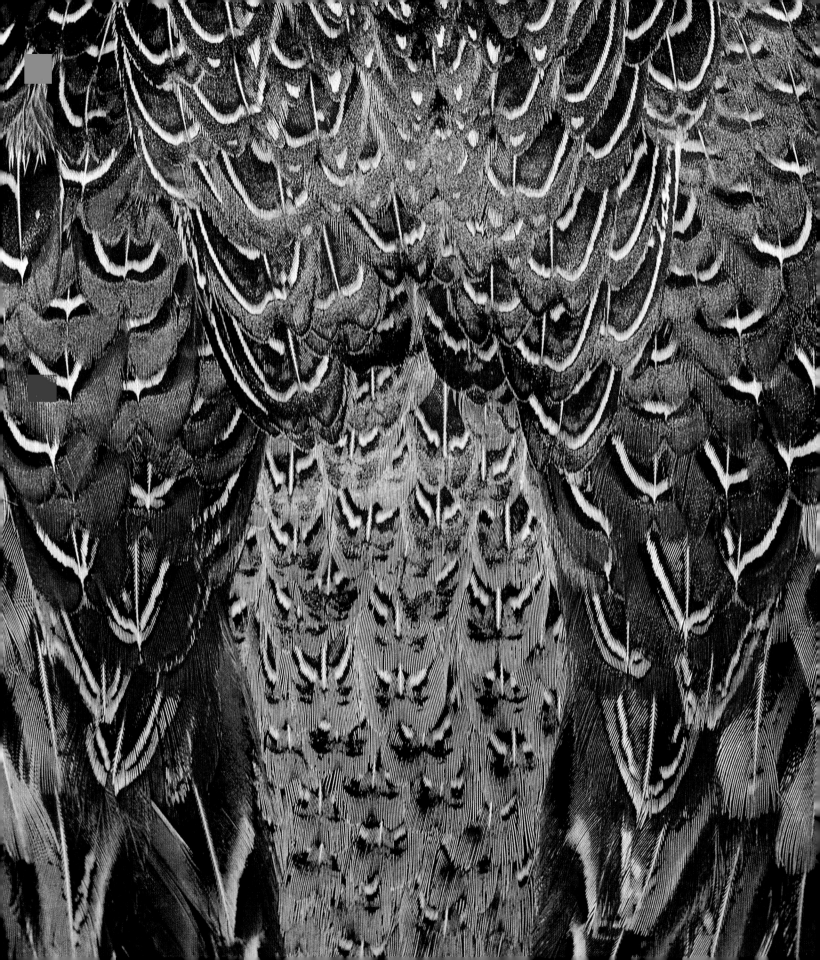

Long-Tailed Pheasants

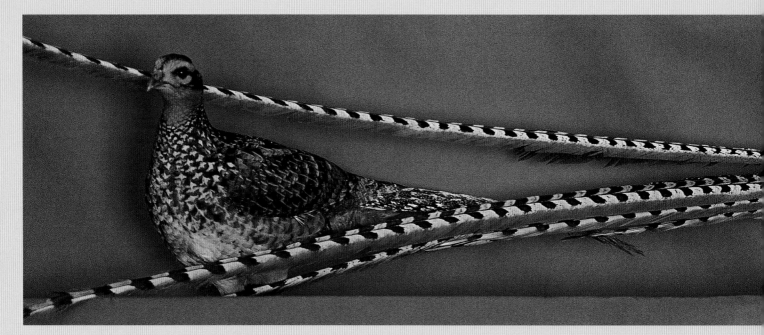

Reeves' Pheasant Hen

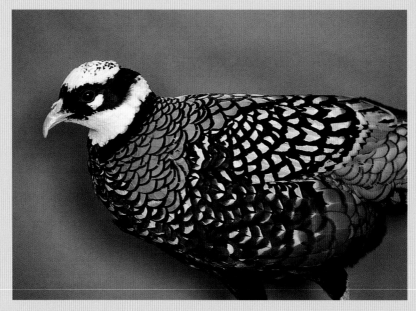

Reeves' Pheasant

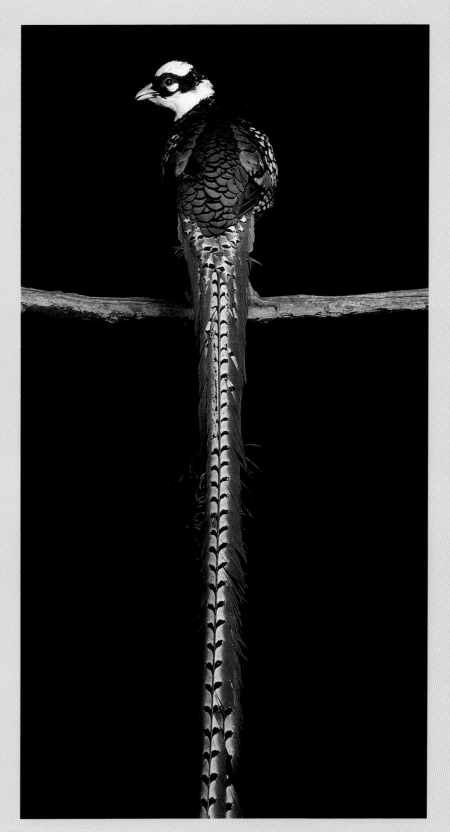

Reeves' Pheasant

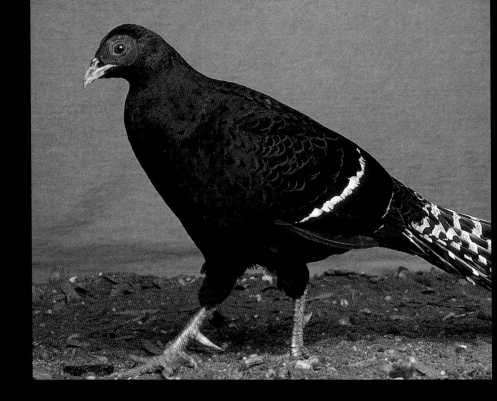

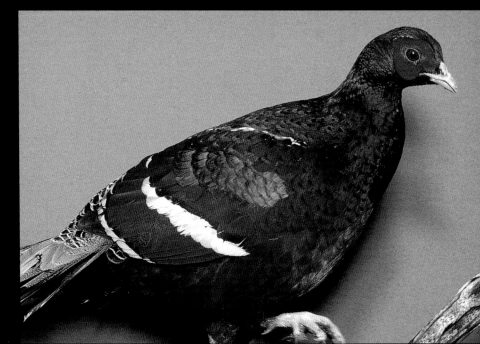

ABOVE:
Mikado Pheasant

BELOW:
Hume's Pheasant

OPPOSITE PAGE:
Elliot's Pheasant

OVERLEAF:
Ijima Copper Pheasant

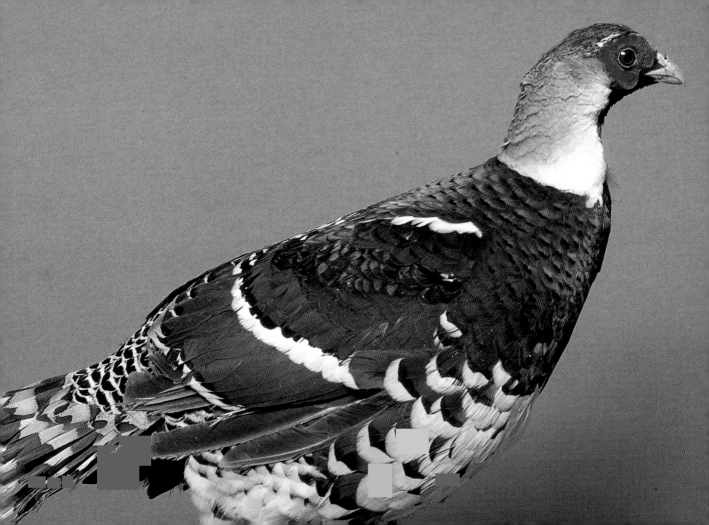

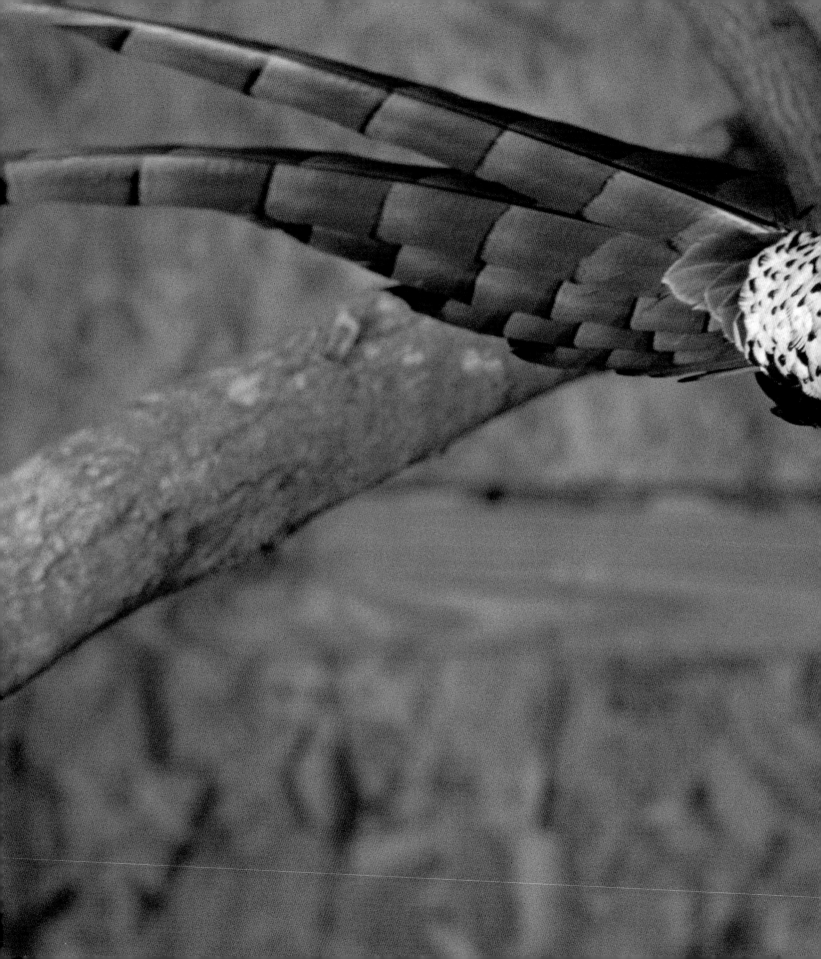

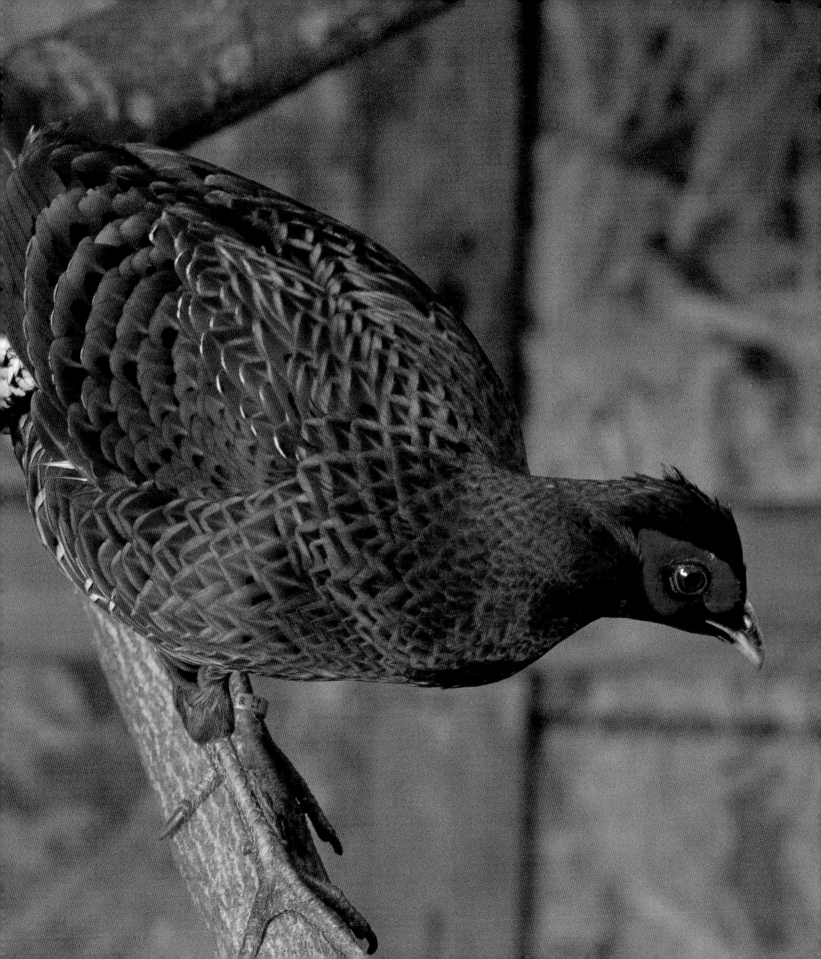

True Pheasants

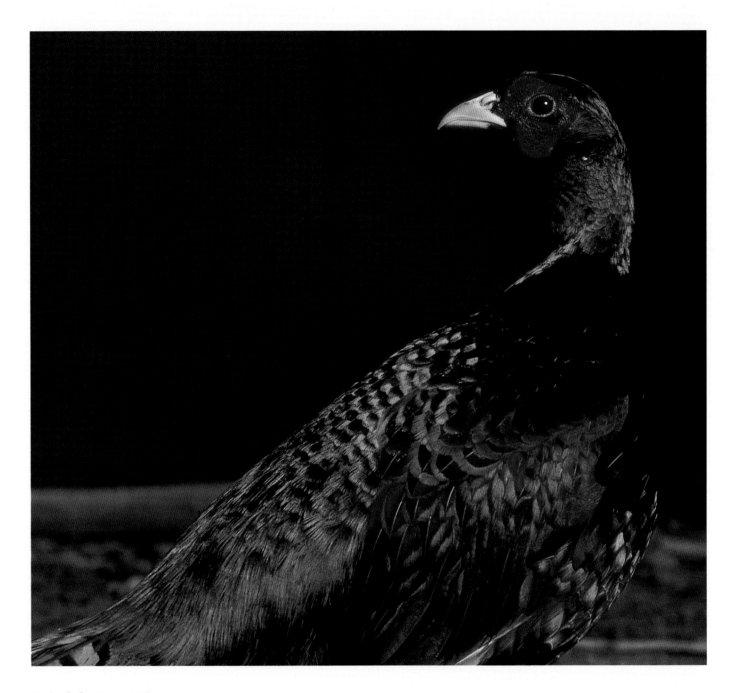

Melanistic Mutant Pheasant

OPPOSITE:
Green Pheasant

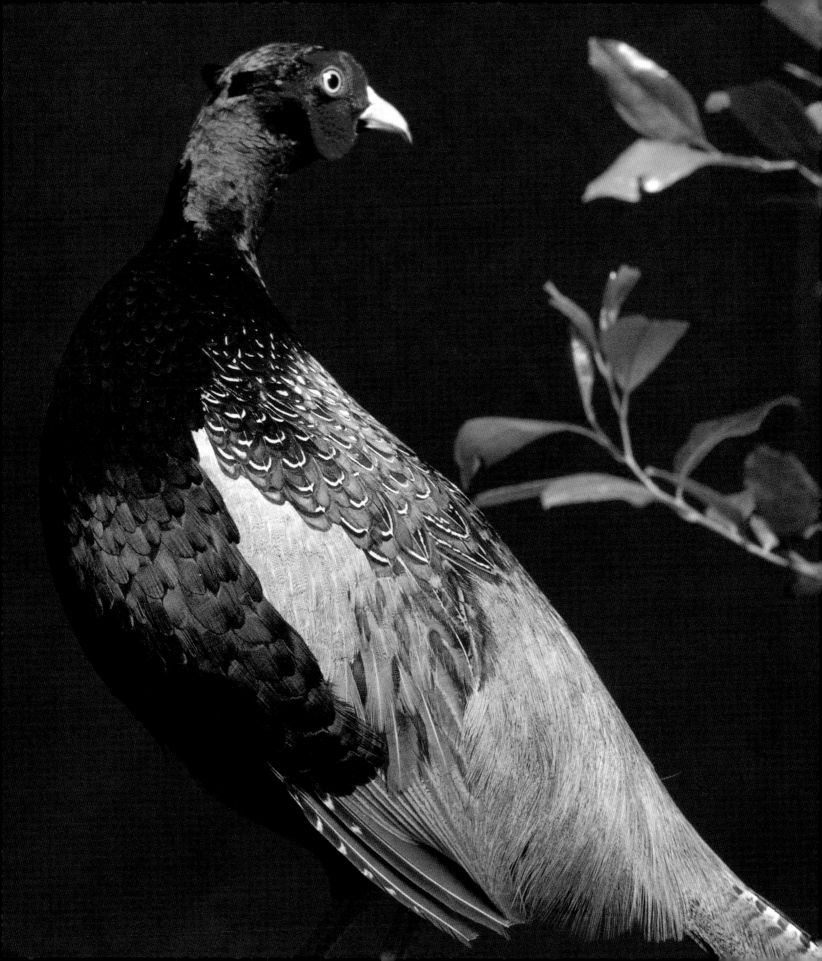

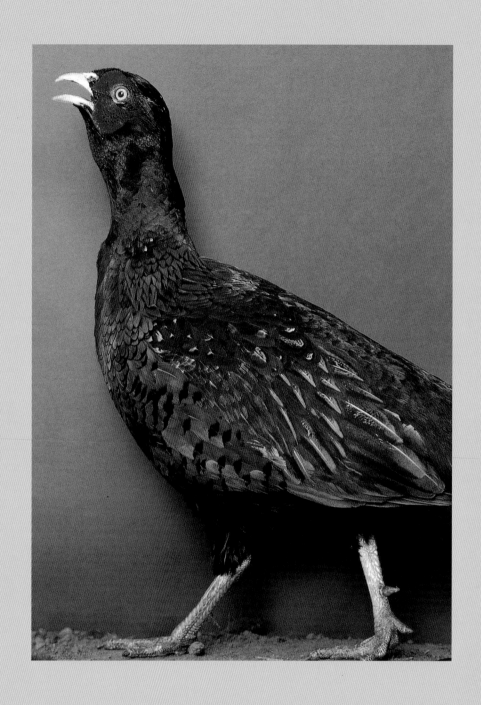

ABOVE
Talisch Pheasant

OPPOSITE:
Black-Necked Pheasant

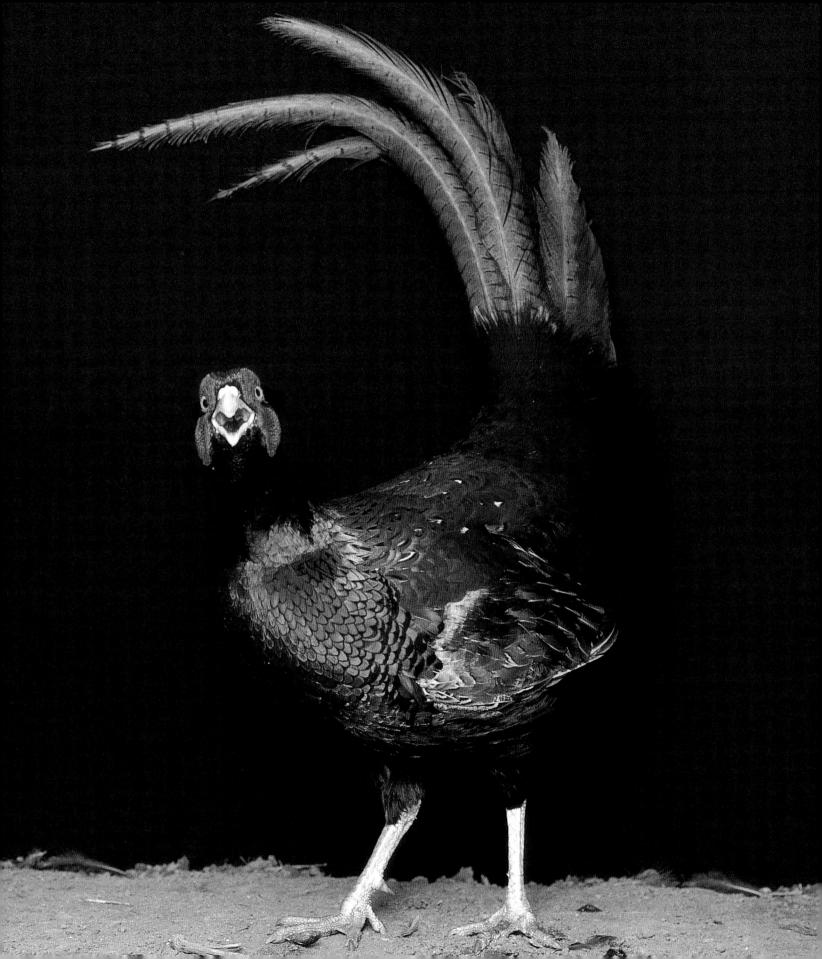

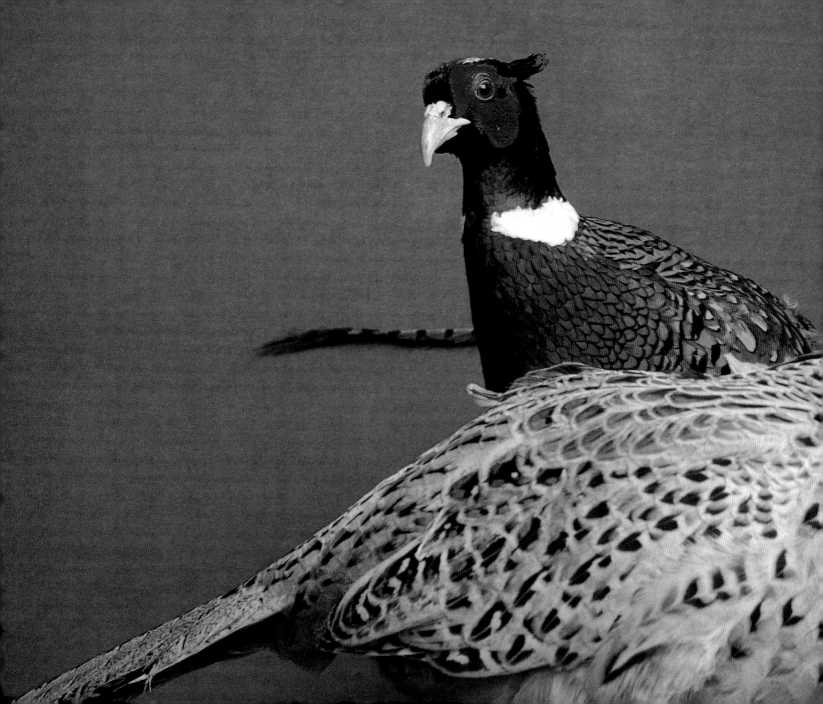

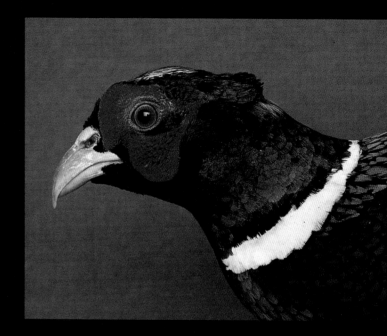

Ringneck Pheasant

Ringneck Pheasant and Hen

Ruffed Pheasants

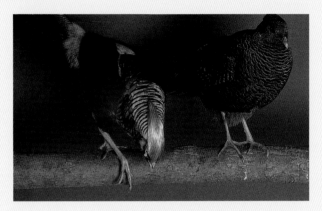

Dark-Throated Golden Pheasant—Pair

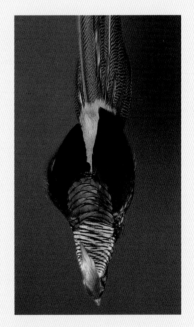

Dark-Throated
Golden Pheasant

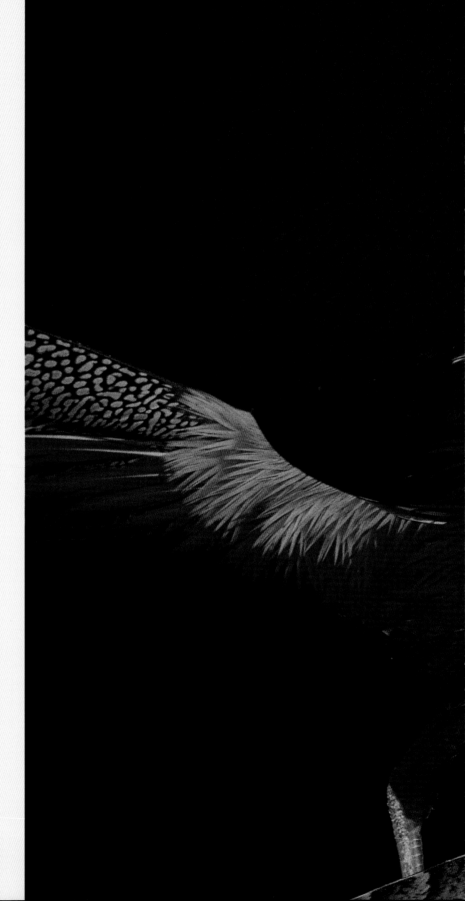

Golden Pheasant—Pair

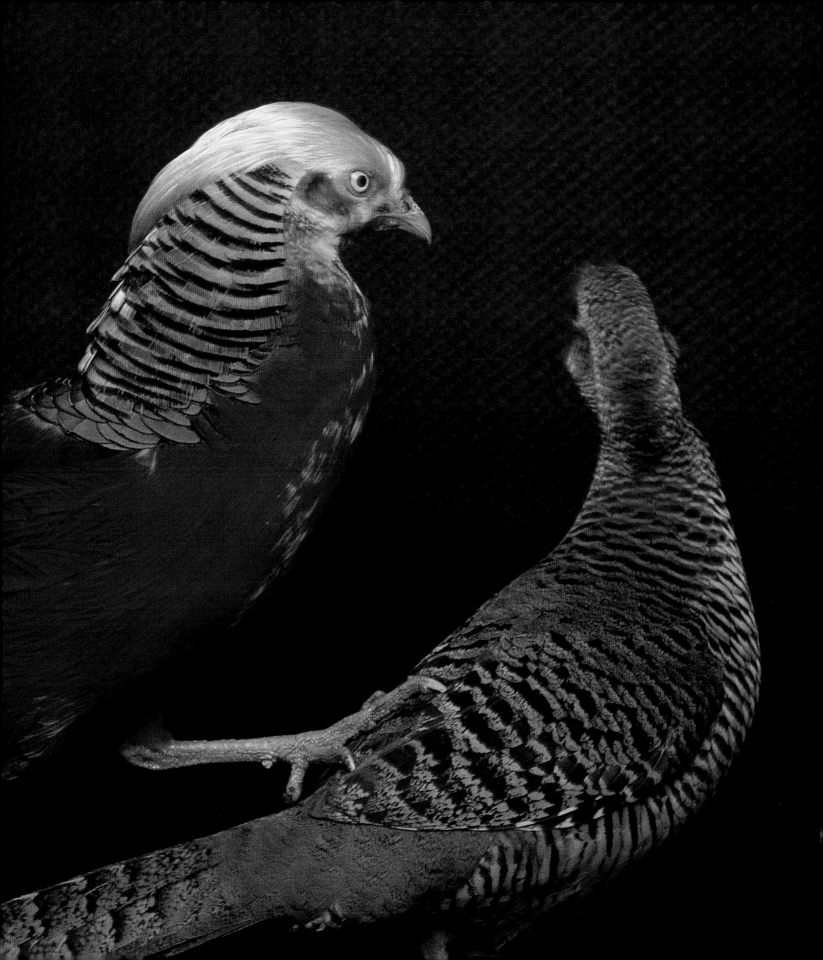

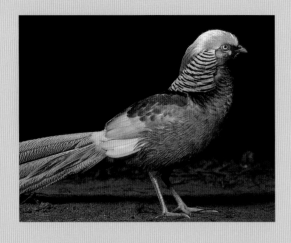 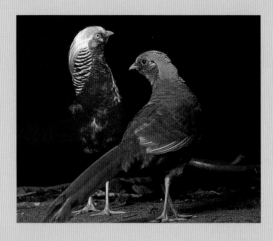

LEFT:
Salmon Golden Pheasant

RIGHT:
Cinnamon Golden
Pheasant—Pair

BELOW:
Silver Golden Pheasant

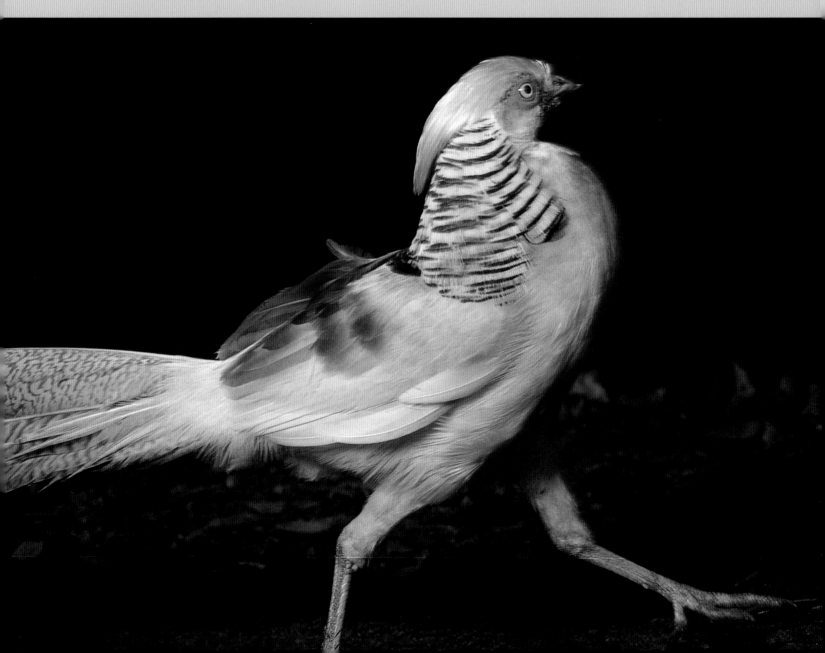

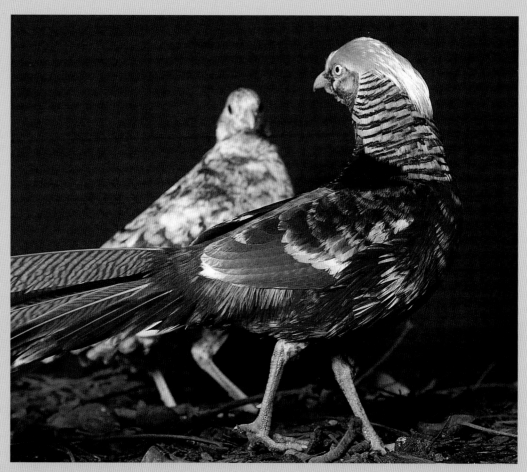

Splash Golden Pheasant—Pair

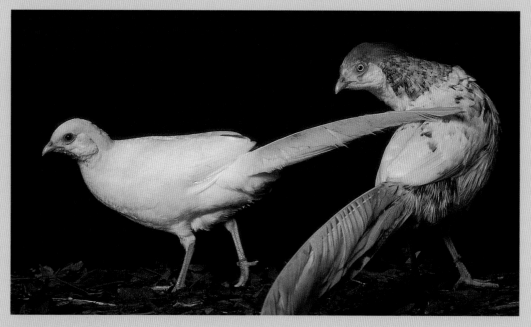

Peach Golden Pheasant—Pair

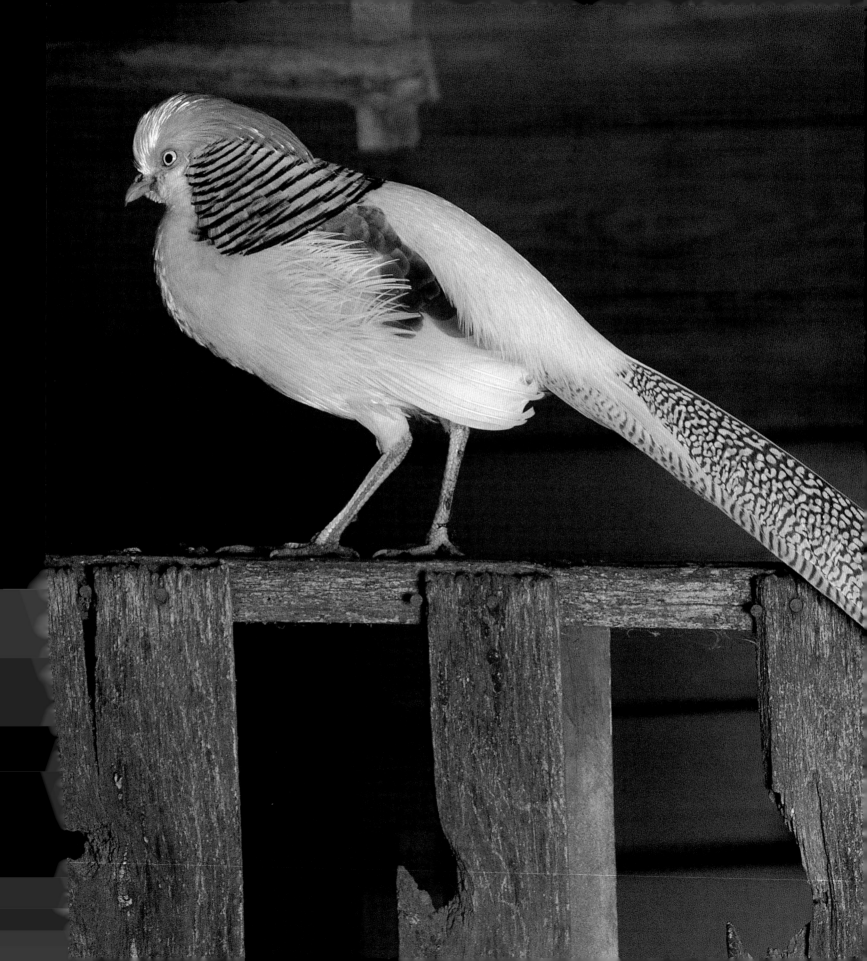

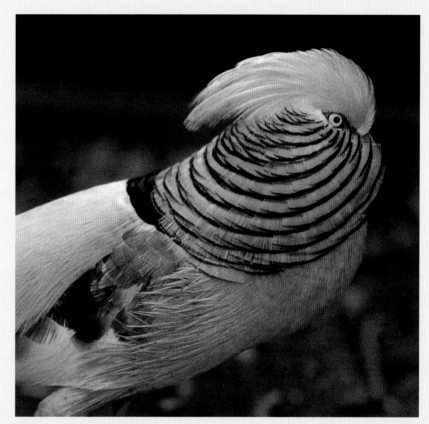

Ghigi Pheasant

Ghigi Pheasant

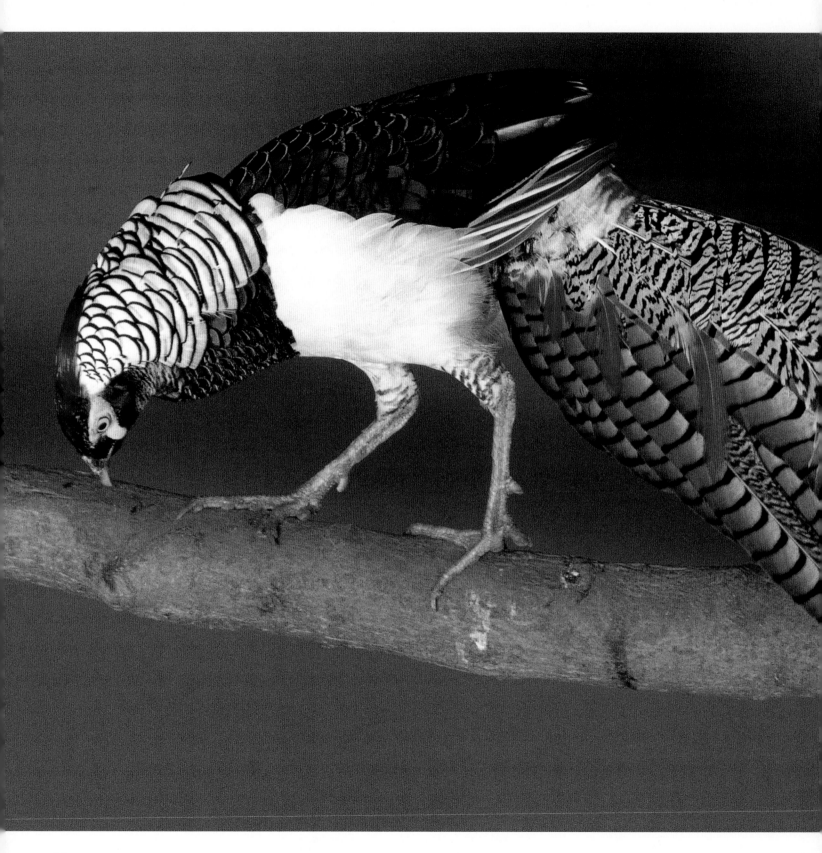

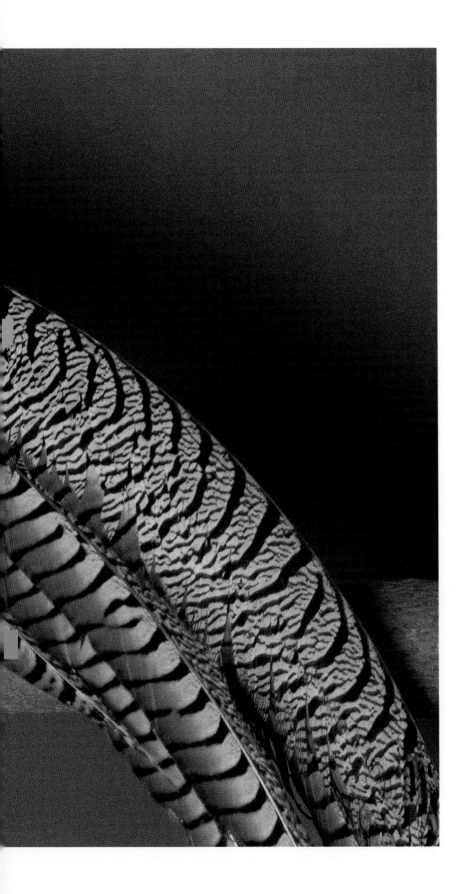

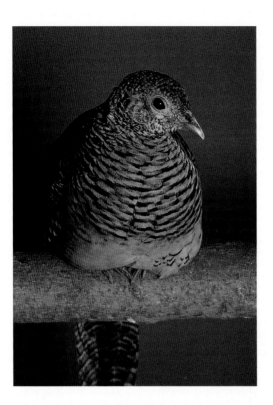

Lady Amherst's Pheasant Hen

LEFT AND BELOW:
Lady Amherst's Pheasant

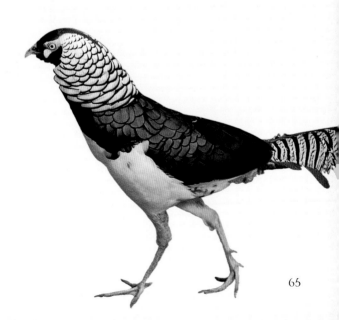

65

Peacock Pheasants

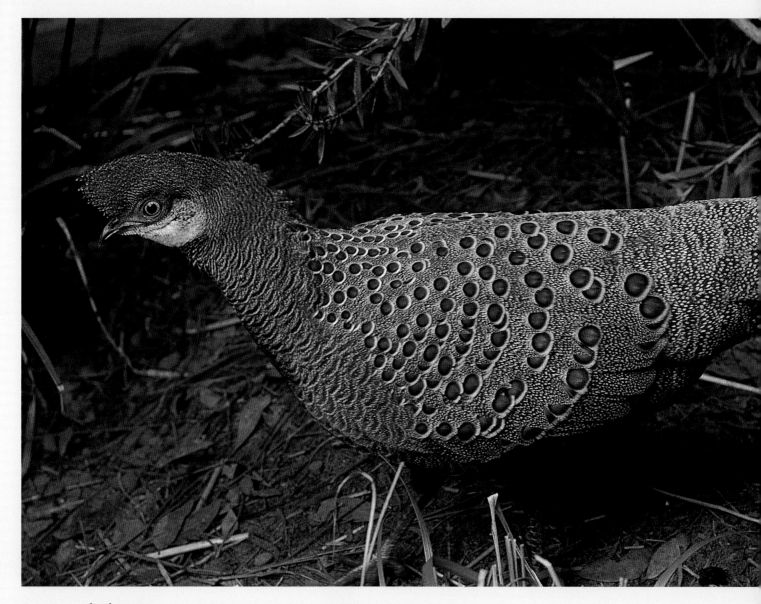

Grey Peacock Pheasant

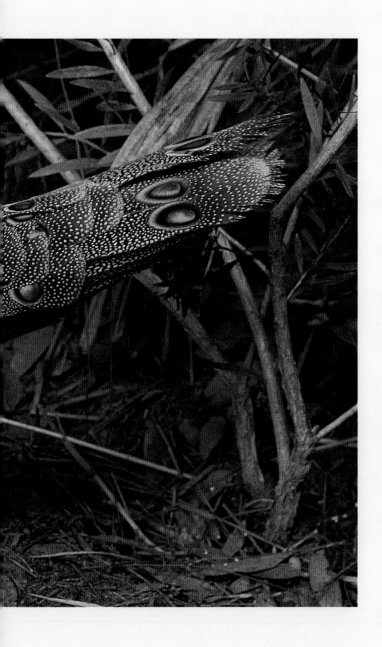

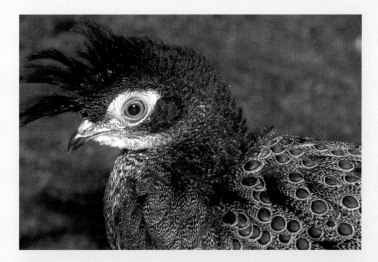

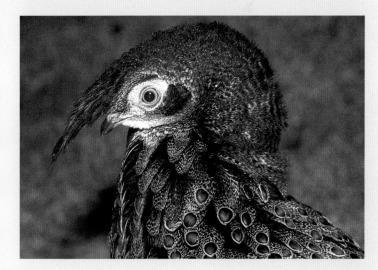

Malay Peacock Pheasant

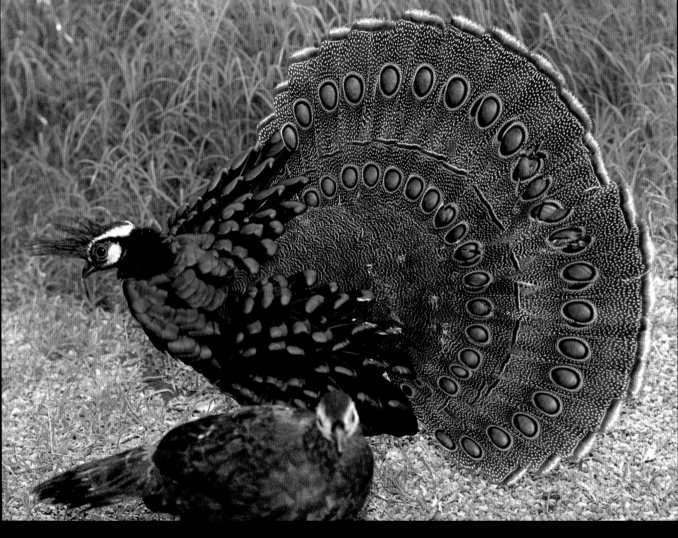

Palawan Peacock Pheasant—Male Displaying to Hen

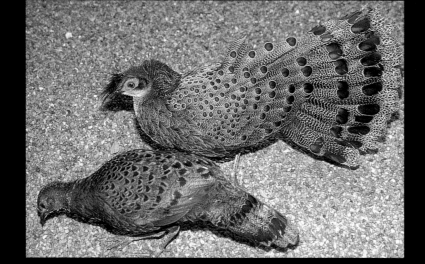

LEFT
Malay Peacock Pheasant—Pair

RIGHT
Germain's Peacock Pheasant

BELOW
Rothschild's Peacock Pheasant—Pair

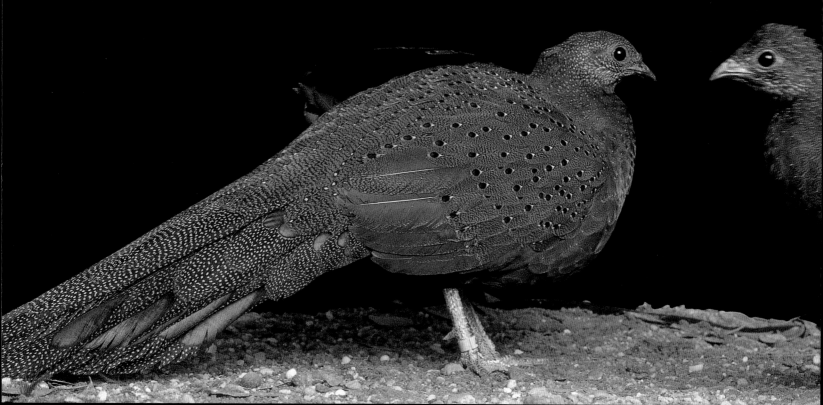

Great Argus

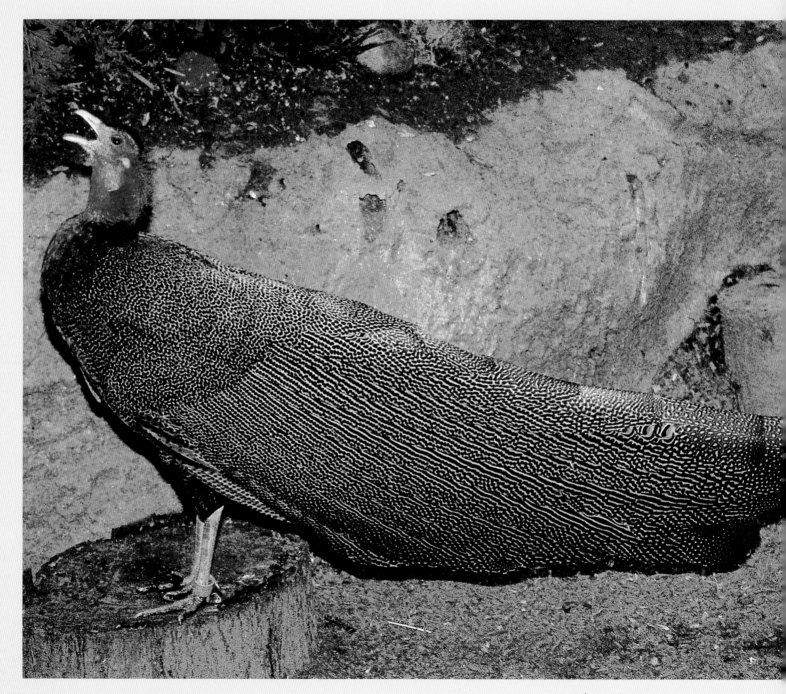

Great Argus

Great Argus—Juvenile

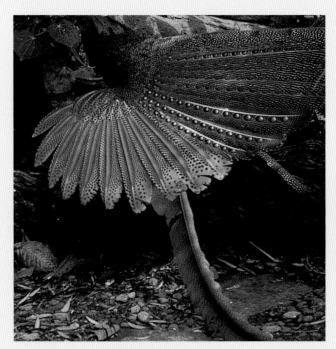

Great Argus—Preening

Congo Peafowl

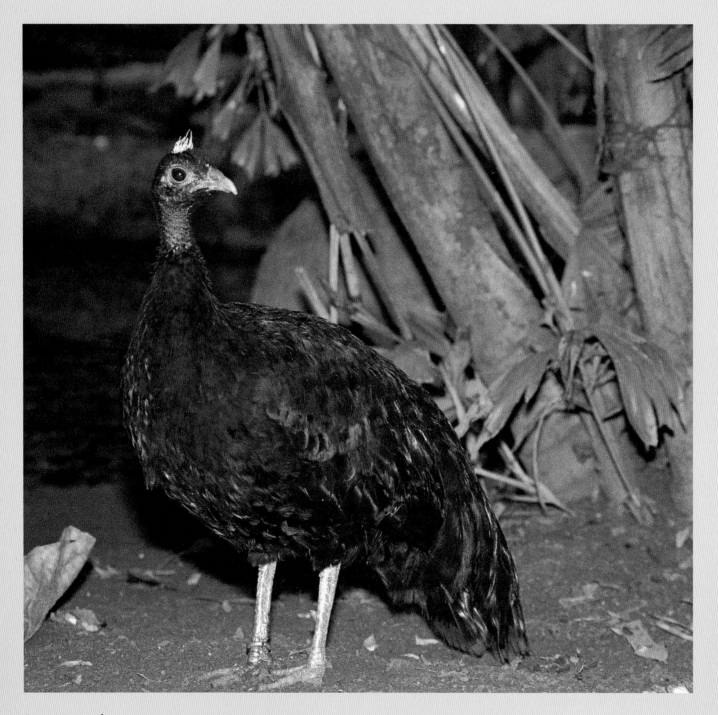

Congo Peacock

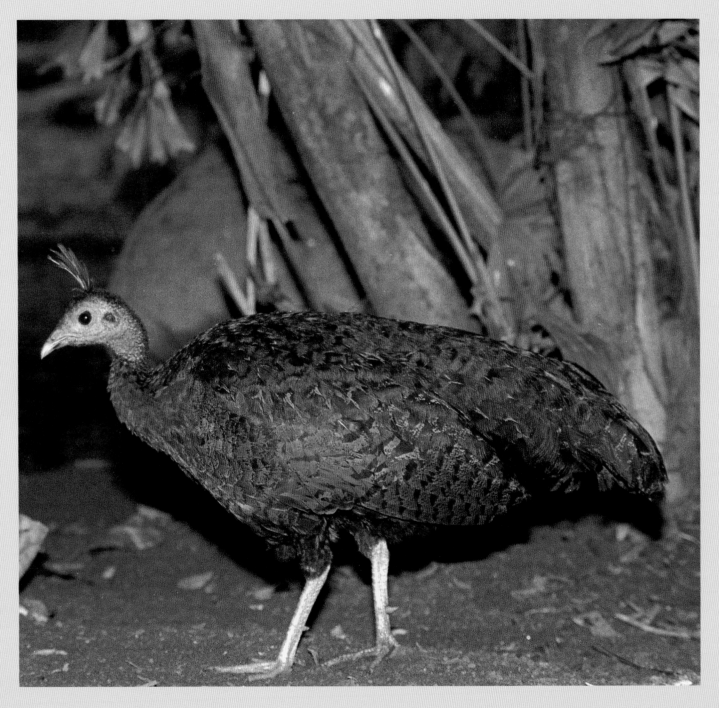

Congo Peahen

Peafowl

 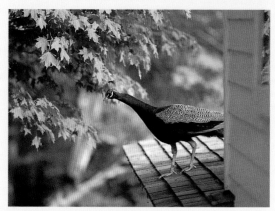

Indian Blue Peacocks

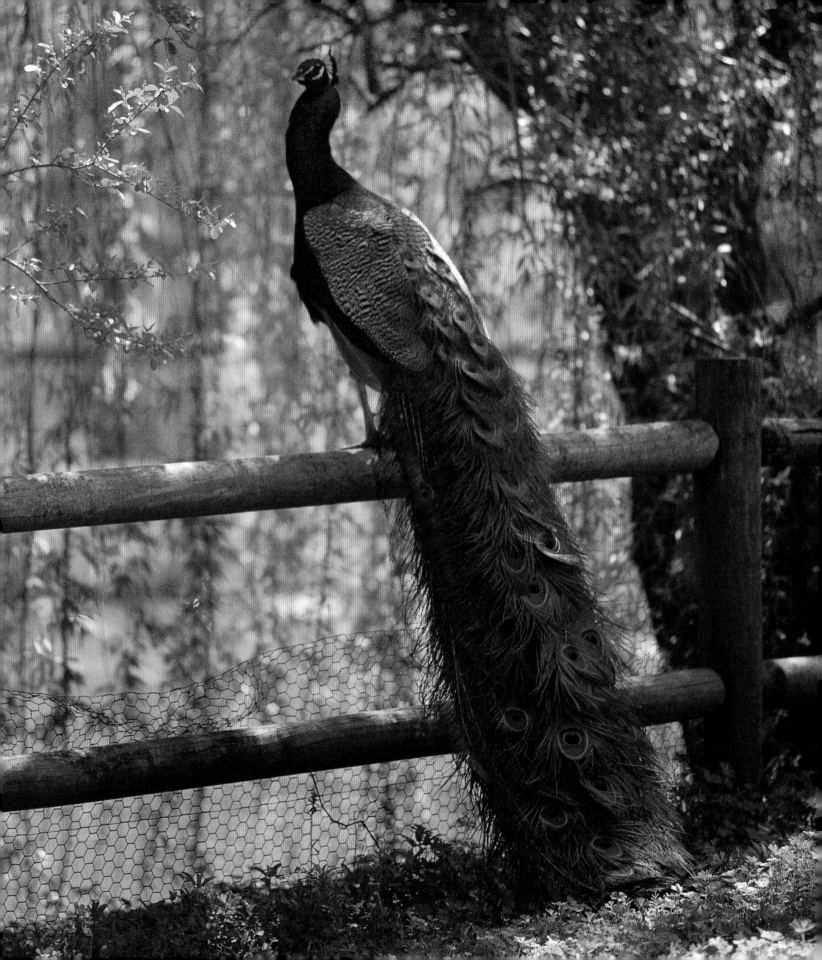

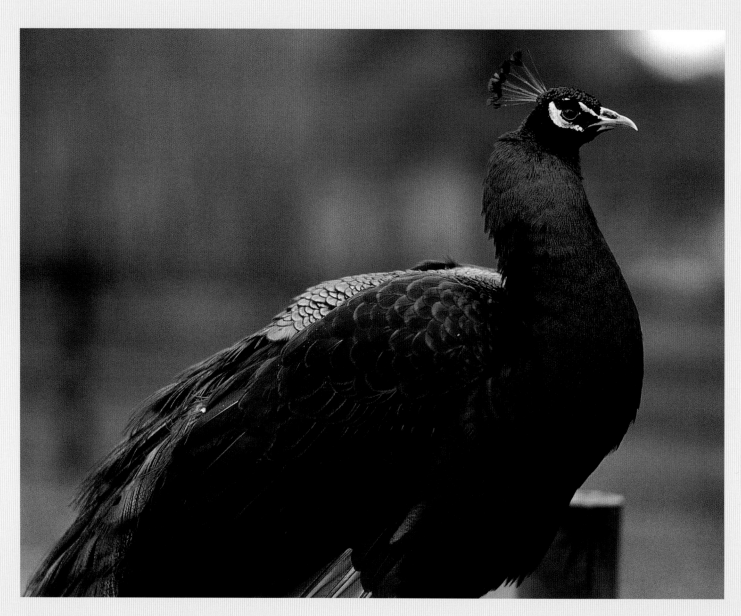

Black-Shouldered Peacock

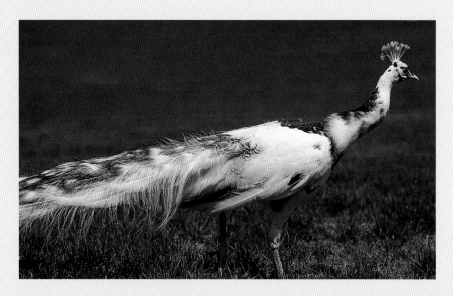

Silver Pied Peacock

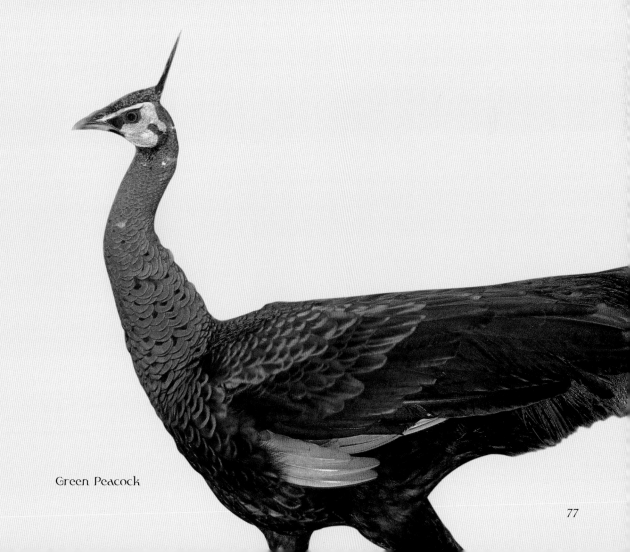

Green Peacock

Peafowl Heads
and Necks

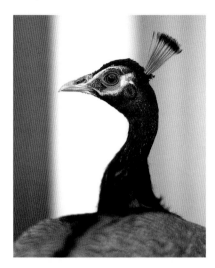

Charcoal Peacock

OPPOSITE PAGE:
Green Peacock

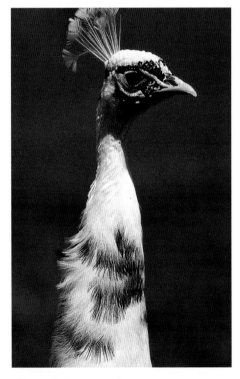

Silver Pied Peacock

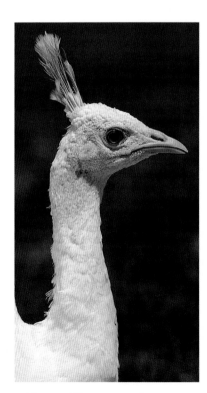

White Spalding Peacock

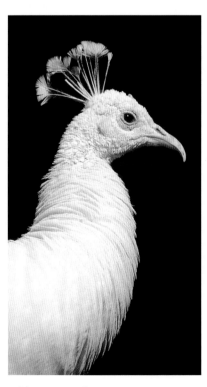

White Peacock

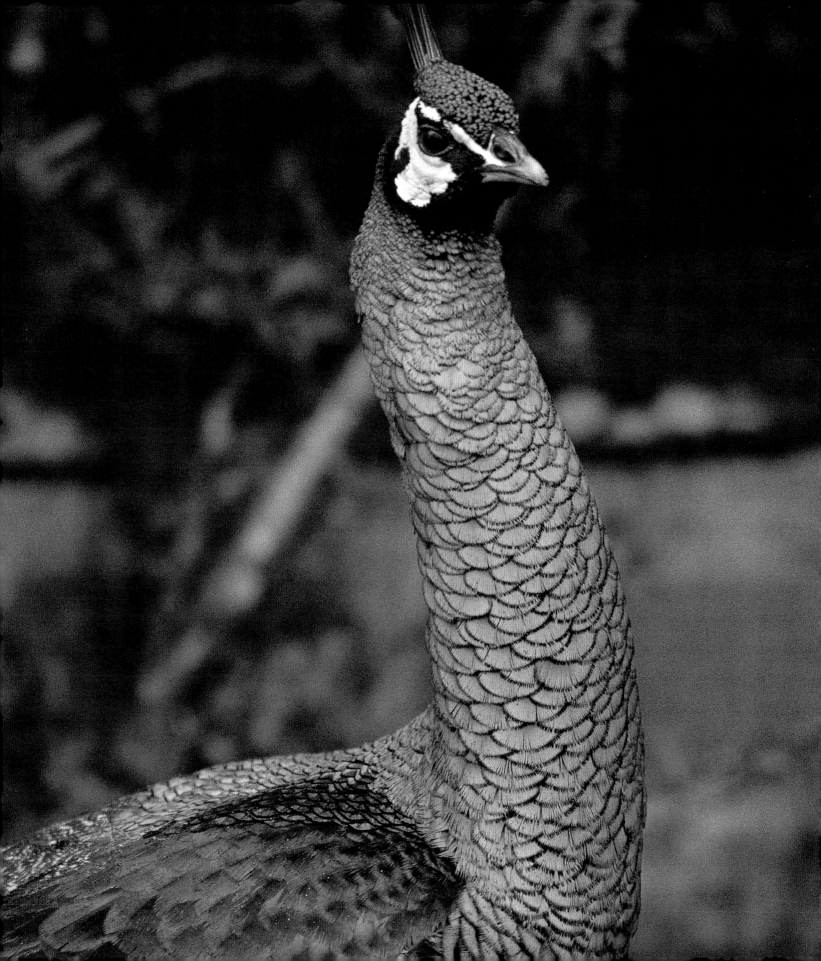

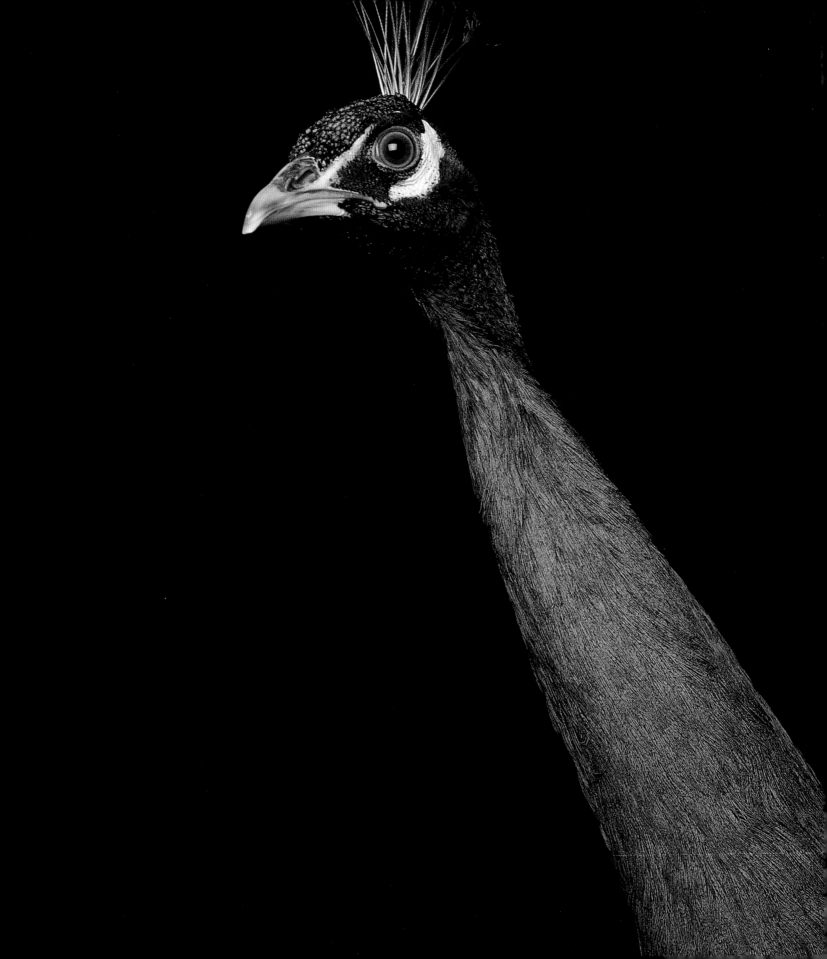

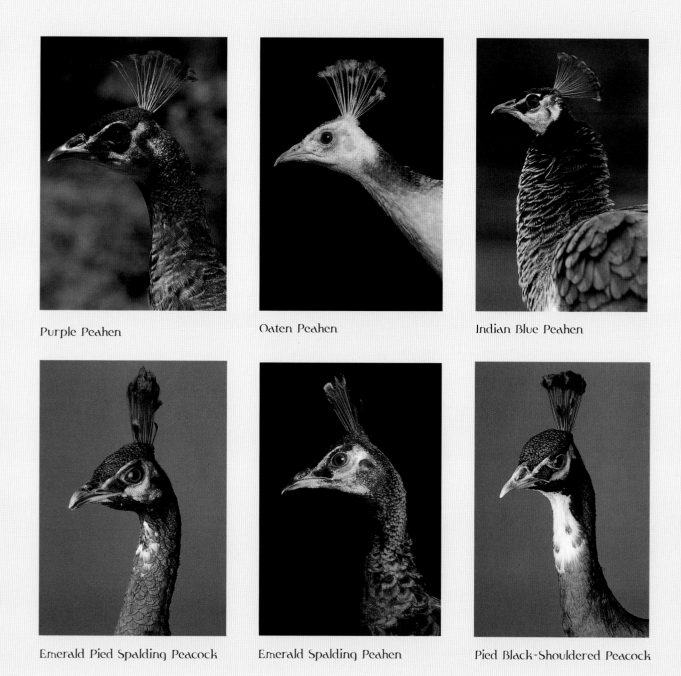

Purple Peahen Oaten Peahen Indian Blue Peahen

Emerald Pied Spalding Peacock Emerald Spalding Peahen Pied Black-Shouldered Peacock

Purple Peacock

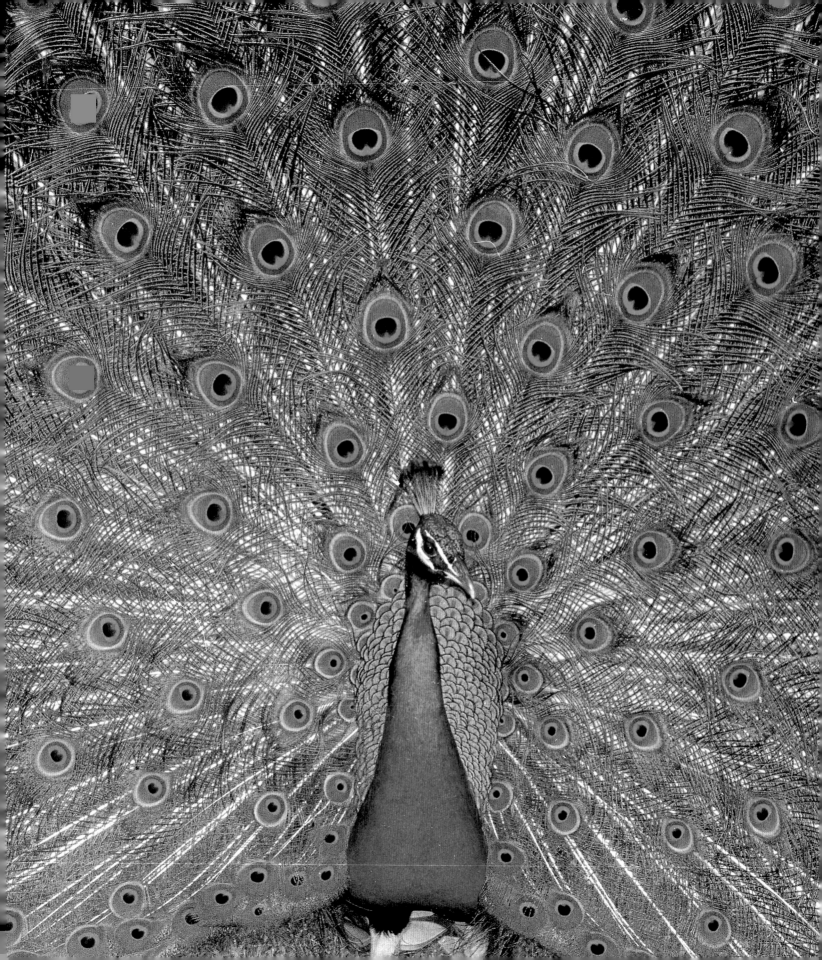

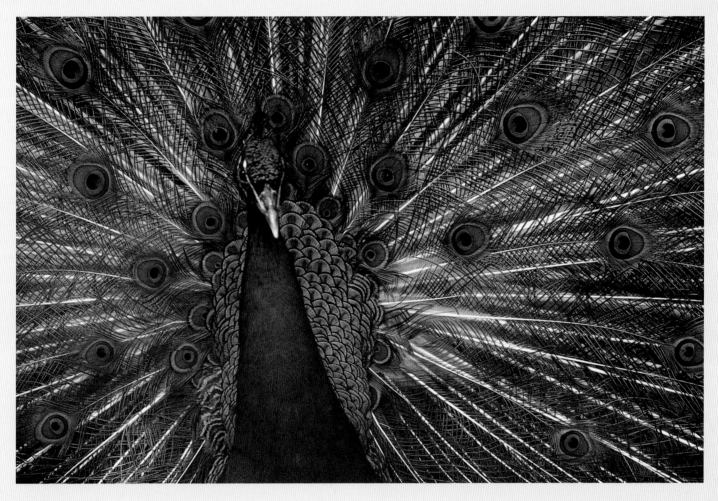

Purple Peacock

OPPOSITE PAGE:
Indian Blue Peacock

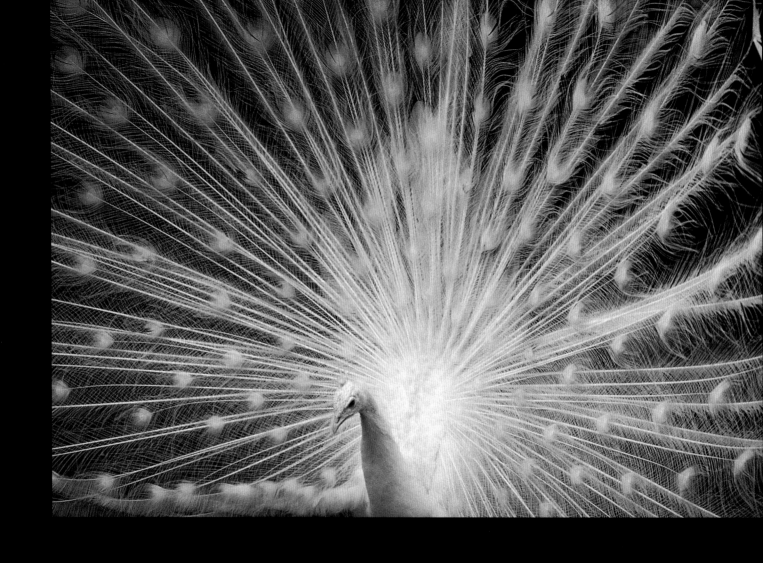

ABOVE: White Peacock

OPPOSITE ABOVE: Buford Bronze Peacock

OPPOSITE BELOW: Cameo Peacock

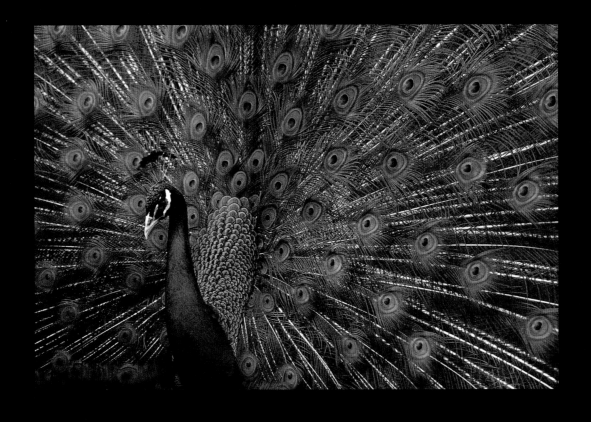

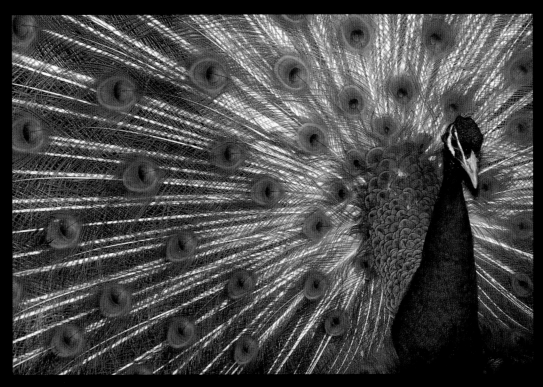

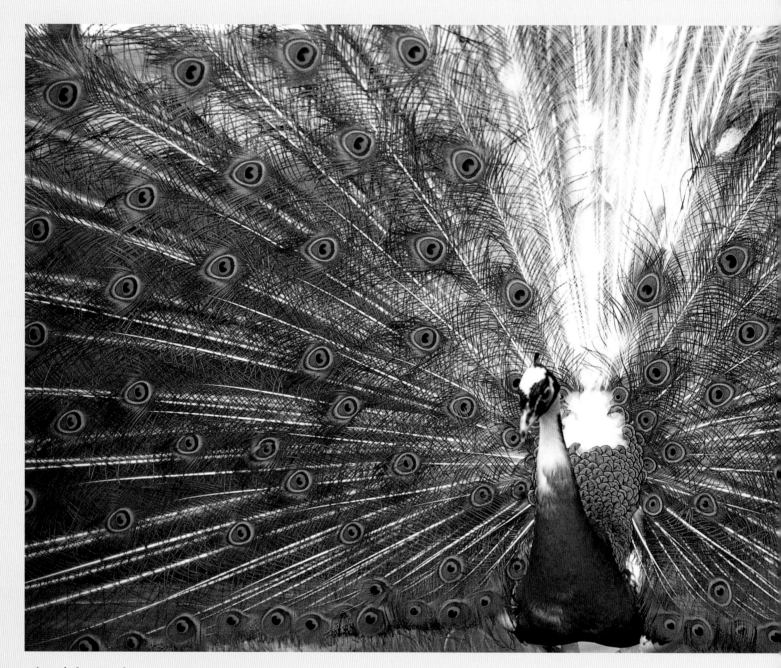

Blue Pied Peacock

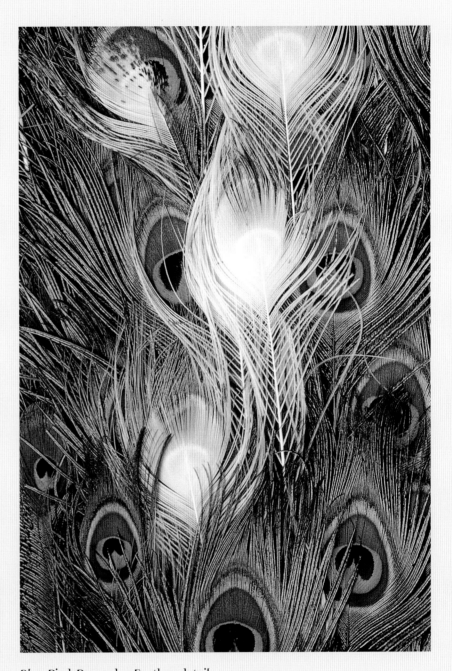

Blue Pied Peacock—Feather detail

OVERLEAF:
Peafowl—Feather details
See page 112 for fuller descriptions.

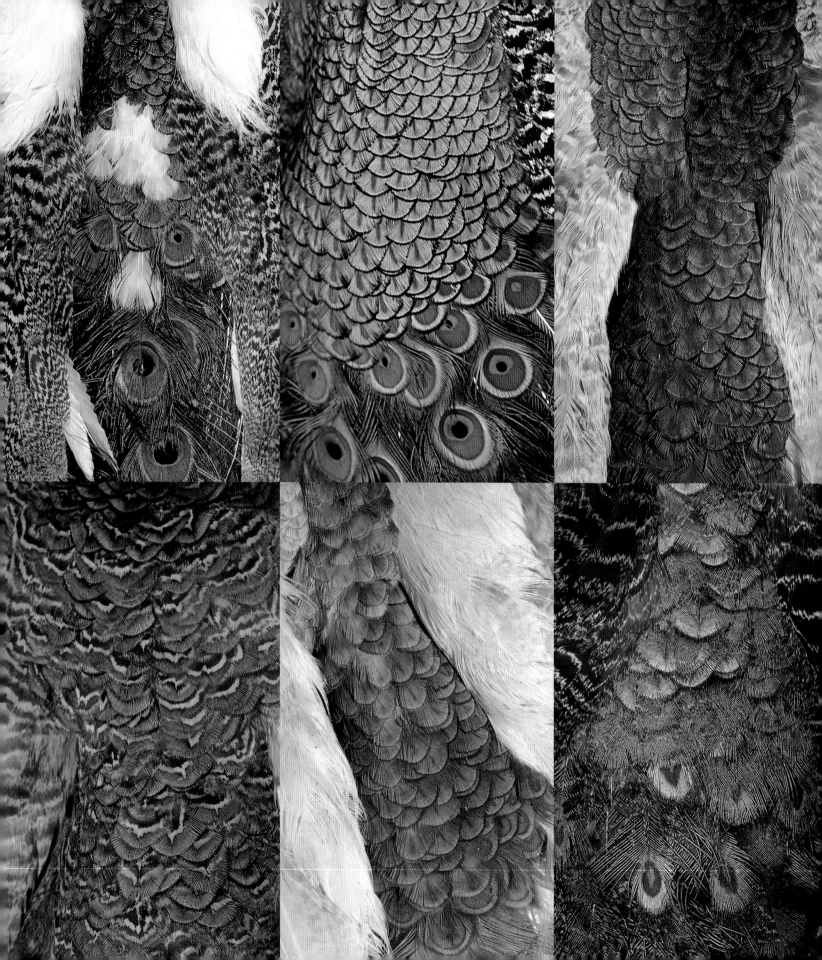

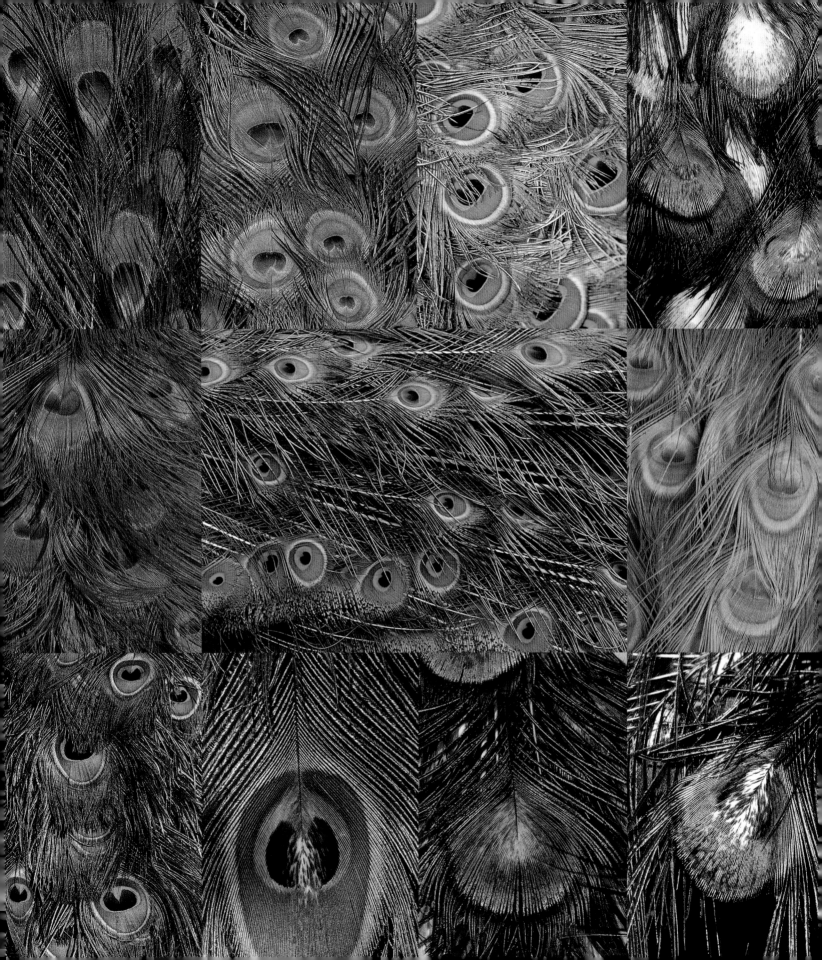

THE PHEASANT FAMILY:

Brief History and Classification

Malay Crested Fireback

Pheasants belong to a large group of birds that includes some domestic fowl and many other game birds. Chickens are their descendants, and partridges are closely related. Turkeys both wild and domestic are part of the same family, classified as Galliforms, as are Australian Brush Turkeys, Guinea Fowl, Francolins, and Curassows. New World and Old World Quail are related, as well as Grouse.

Biologists seem to be in agreement as to what makes a pheasant a pheasant. Perhaps if one can accept that Great Danes, English Bulldogs, and Mexican Chihuahuas are actually of the same species, it might be reasonable to accept Peacocks and Ringnecks as being related species. Anyway ornithologists consider skeletons, feathers, geography, habits, and, among other factors, the sequence in which tail feathers molt, in defining the members of the pheasant family.

William Beebe placed pheasants into four main groups: the partridgelike Perdicinae, which included Tragopans, Monals, and Blood Pheasants, all with fairly sturdy physiques and short tails; Pavoninae were peafowl; Argusianinae included the Peacock Pheasants with the Argus; the rest were all Phasianinae—Gallinaceous. Today we group pheasants into sixteen genera, within which exist about fifty species. If one adds subspecies and mutations, the total is closer to two hundred.

Classified as pheasants are four species of Jungle Fowl, and they do indeed look like rather wild versions of domestic fowl. Scientists have long suspected that our farmyard birds were descended from them, and we now know that it is specifically the Red Jungle Fowl that is the ancestor of the billions of chickens that have helped to feed so much of the planet for so many centuries.

Paleontologists have found evidence of large pheasantlike birds roaming Europe in the Miocene era, but those we know today are from Asia. Indeed, the earliest painted images of pheasants are seen in Chinese art dating to about thirty-five hundred years ago. With the peculiar exception of the Congo Peacock (which was not known to science until recently), the various Asian species ranged from the Caucasus to China, being found on both sides of the Himalayas, down into India and Southeast Asia. In the geological past, many of the islands in that part of the world were joined to the mainland, so some

Malay Peacock Pheasant

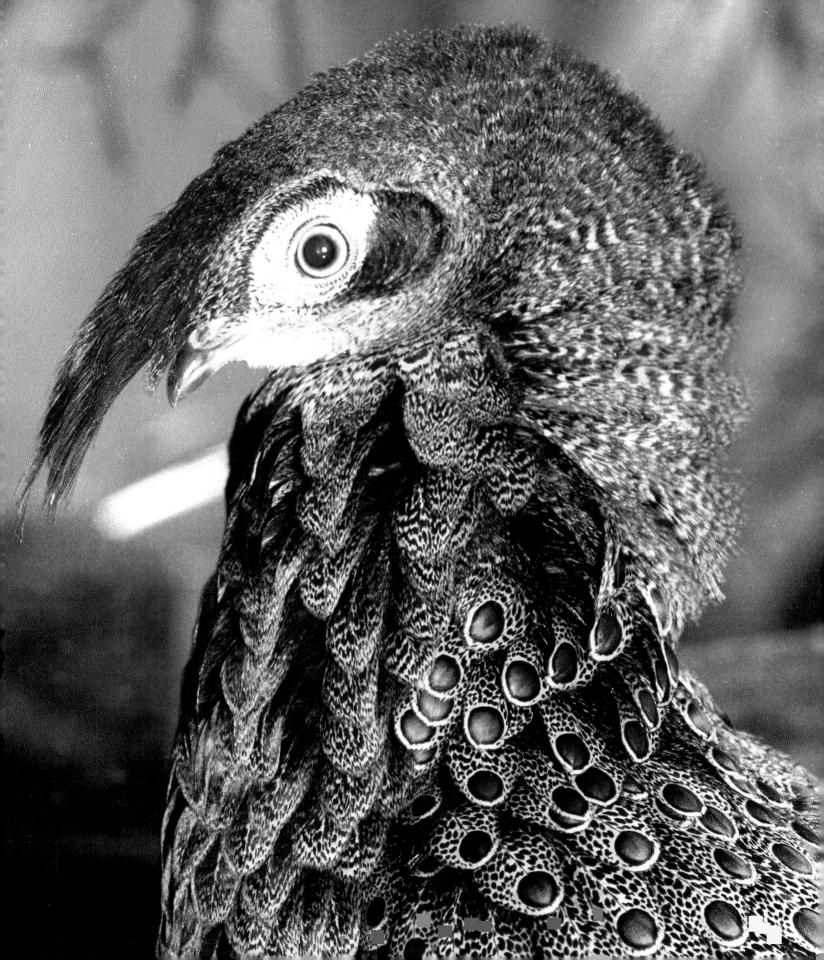

species that were once able to move freely over the entire area later became separated, and evolved into distinct but related species.

Pheasants are not migratory by nature, and their geographical spread has been gradual. One could get a false impression of their migration activity by observing the range of pheasants throughout many continents today. None of these birds flapped their relatively short wings to cross oceans and continents. Clearly humankind has been involved in spreading them, whether for the sake of food, sport, or ornament.

Prior to human intervention, the westernmost extent of pheasant populations was the area between the Caspian Sea and the Black Sea, including the countries of the Caucasus that were until recently part of the Soviet Union. It is believed that pheasants were brought westward about twenty-five hundred years ago from this region. The mythical Greek heroes Jason and the Argonauts were said to have brought them from Colchis, which had been the destination of the *Argo*. Colchis no longer exists in today's geography, but it lay at the eastern end of the Black Sea, and its boundary with Asia Minor was the river Phasis, from which we get the genus name *Phasianus*. What we now call the True Pheasant carries the Latin name of *Phasianus colchicus*. The river Phasis has also disappeared from modern maps; it is now called the Rioni, flowing down from the Caucasus Mountains into a wide fertile valley as it joins the Black Sea.

Phasianus colchicus was spread farther west into Europe by the Romans, and the species was well established in several countries by the time pheasants were imported from China. Though these pheasants had always been hunted for food, in the nineteenth century it became popular to keep captive birds, particularly in France and England. They were admired for their plumage and needed for the meat and eggs they supplied. Those of the Pavoninae group, the peacocks, were to be found mainly on the estates of the wealthy and aristocratic; like mobile flower beds, they added beauty to lawns, terraces, and formal gardens.

Over the millennia, different pheasant species have evolved to exploit the particular conditions of regional terrain and food supply. Certain species, for example the Tragopans, Monals, and Blood Pheasants, prefer high country, being comfortable in the Himalayas at altitudes up to 16,000 feet. Naturally advancing and retreating snow lines will dictate some movement, and in all cases pheasants, like other creatures, will move to where food sources are in season. For many, a temperate climate is preferable, often with hills and varied terrain. Other species are tropical, usually living in dense jungles. It is not surprising to find Jungle Fowl in this kind of habitat. Firebacks, Peacock Pheasants, and the distinctive Bulwer's Wattled Pheasant are also jungle-dwellers. In some cases, this puts them around sea level, and pheasants have been spotted close to the surf line.

Pheasants spend most of their waking lives on the ground. They are capable of very fast flight, but their wings are small in relation to their body weight, and they cannot sustain flight for any distance.

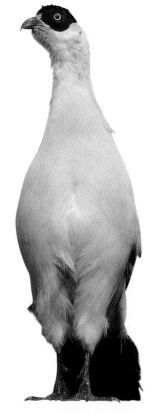

White Eared Pheasant

Generally speaking, they move around the landscape on foot, and only take to their wings in emergencies. In hilly or mountainous terrain they will almost always fly downhill, using gravity to increase speed and acceleration. Like wild turkeys, they will often escape danger by running instead of flying.

Most birds roost in trees for the night, and pheasants usually do so well away from the tree trunk so as to have some warning time if a mammal predator is approaching along their chosen branch. Dead trees without bark are less likely to be climbed by animals, but absence of foliage above them can make roosting birds vulnerable to large owls.

Members of the Tragopan genus actually nest in trees, often making use of existing structures, but all other species find a well-hidden spot for a ground nest. The hen alone will sit on the eggs, and her coloring and subtle feather patterns usually blend well with the vegetation. Some hens lay a dozen or more eggs, though Tragopans may lay as few as two. Eggs hatch in about three weeks for most pheasants, around four with Peafowl.

Prior to mating, many male birds display to the hens in different ways. We are all familiar with the huge fan that the peacock deploys. The much smaller Peacock Pheasants do the same thing, though usually it is a lateral display, allowing the female to see more of her suitor's body. Ruffed pheasants such as the Golden and the Lady Amherst's make a much smaller lateral display, just fanning out the feathers on the ruff or mantle at the neck, and cocking their heads sideways in the direction of the object of their desire. They may also do this as a warning to rival males, together with an audible hiss.

Some species try to impress each other by standing rather upright and whirring their wings. Tragopans have a very distinctive display, expanding loose skin at their throat to present a sudden bib or *lappet* in front of the chest. It is brightly colored with bold geometric patterns. Dave Rimlinger, the curator of birds at the San Diego Zoo, advises owners to place rocks or logs in the Tragopan enclosure, since the males like to add to the surprise of this little show by bursting out from behind a solid object in a Jack-in-the-Box effect—"Peek-a-Boo, you gorgeous hen." Another strange sight is the display of the Bulwer's Wattled Pheasant, whose blue wattles on either side of the head can extend suddenly, both upward and downward. At the same time his very narrow white tail will curve up over his back to form an almost complete disk.

Alas, the voice of a pheasant does not match the beauty of its feathers—there is no song. The Argus, however, has a one-note call that is as rich as that of a musical instrument and can carry great distances. This is a solitary bird, and his call is an invitation to hens and a warning to other males. Of course it can also inadvertently serve as an advertisement to predators. Eared Pheasants sometimes make a rather endearing soft hooting noise, but the sound that a peacock makes is anything but soft—rather like a very loud and angry Siamese cat. Most species have a strident call when alarmed, but Kalij and Silver Pheasants make a pleasant noise, a kind of contented muttering sound, as they enjoy their foraging activities.

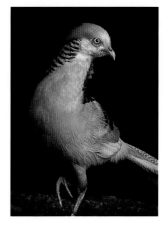

Ghigi Pheasant

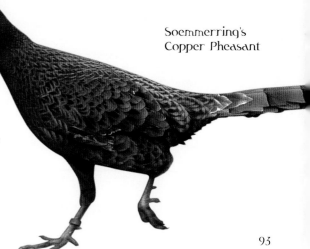

Soemmerring's
Copper Pheasant

They might be foraging for items just under the surface—roots, tubers, and meal-worms. Grubs and beetles and most other insects are welcome, but they learn that some butterflies taste bad. Most will eat leaves, and fruit and berries are taken in season. However, gorging on in-season items can make them too heavy to fly effectively out of danger; perhaps they feel that this is not such a bad way to go.

While being the world's most popular game bird, the pheasant is also immensely popular with aviculturists. The breeding and collecting of birds in private aviaries is a very satisfying hobby, and pheasants seem more charismatic and more beautiful than most of the other species that are bred and raised in captivity.

The most knowledgeable breeder of pheasants in the early part of the twentieth century was the Frenchman Jean Delacour. In addition to enjoying the beautiful specimens, he wanted to observe their behavior to learn more about their habits in the wild. He was inspired by the field work and the research and writing of his friend and fellow scientist William Beebe, whose *Monograph of the Pheasants* is one of the great works of natural history. Sadly, Delacour's collection was destroyed near the end of World War I, when his family home was damaged. The period between the wars saw a huge growth in captive breeding, not only in Europe, but also in India, Japan, Australia, and both North and South America. Delacour again established an outstanding program, going to Asia himself and using agents to acquire a wide range of new species and to add fresh blood to existing gene pools. Tragically, his work was again destroyed by war, but his home is now a public zoo, and his knowledge and experience have survived to be passed on to others (see Further Resources, page 111).

Aviaries in the United States and Canada had not been affected by World War II, and have therefore been able to maintain good breeding stocks of many species, including those that are endangered in their Asian habitats. Many birds from North America contributed to the restoration of European collections. Now there are regional, national, and international organizations concerning themselves with healthy captive populations, and working with Asian countries on preservation efforts.

In the past, scientists sometimes created deliberate hybrid pheasants with a view to learning how closely related certain species were to each other. It was also possible to put inappropriate birds together unknowingly since different hen pheasants can look very similar. In other cases there was interbreeding simply because the proximity of captive birds to each other could present opportunities that were sometimes appealing to the birds themselves. And of course hybridization can also occur in the wild.

With most captive pheasants, genetic integrity is carefully maintained, A few breeders, however, have become interested in developing different color versions in species that are not endangered. Some aviculturists are not at ease with these activities, but those who are derive satisfaction in being involved with the breeding of birds that can be different and beautiful. For the most part, this experimentation has been restricted to mutations of the Golden Pheasant and the Peafowl, and usually begins with

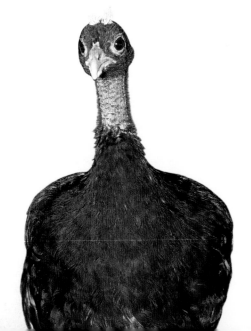

Congo Peacock

changes that have occurred by chance in nature. For example, Professor A. Ghigi in Italy was able to isolate the genetic trait that led to a yellow version of the Golden Pheasant, and he subsequently established the Yellow Golden as a viable subspecies that breeds *true* (meaning that the breeding of two Yellow Goldens will always result in more Yellow Goldens and not some other variant). It is now referred to as the Ghigi Pheasant and can be found in countless private collections. There are now more than a dozen mutations of the Golden Pheasant, with the Dark-Throated Golden dating from as long ago as 1860.

Actually, many recognized mutations first occurred in nature; within the pheasant family, the True Pheasants have been identified as having as many as thirty different subspecies, with and without rings around their necks. White and Black-Shouldered Peafowl were a naturally occurring mutation, and, while Whites continued to be mated successfully with other Whites, breeders have also mated Whites with Indian Blues and others to establish Pied Peafowl.

It seems natural to become emotional about the survival of megafauna—giant pandas, rhinoceros, mountain gorillas, and so on. We have known them since the picture books of our childhood, and gazed with affection and awe at the specimens in zoos. Not many of us have come to care about the fate of Swinhoe's or Edward's Pheasants, or had a chance to admire the spectacular metallic feathers of the Chinese Monal.

There are, however, people who care about the fate of pheasants, and they have formed organizations that act for their preservation. The World Pheasant Association, founded in 1975, does more than study the problem; along with other groups, it publishes a conservation strategy for Galliforms every five years, each time reviewing and assessing the effectiveness of ongoing projects. Unfortunately, the study of wild birds is often difficult. Their habitats can be hard to reach, a problem frequently complicated by local political problems restricting travel. Within many governments, cooperation with concerned biologists does not merit high priority.

Other organizations, both local and global, seek to preserve and extend protected wild areas, reduce pollution, and limit deforestation, all projects that can benefit pheasants as well as other wildlife. Greed, ignorance, indifference, and expanding human populations are common enemies to most ecological concerns, and deforestation is a tragedy that particularly affects members of the pheasant family. Sometimes pheasants feeding on farmland are shot on suspicion of eating crops and seeds, whereas they are more likely to be friends of the farmer by eating insects. Poaching, of course, continues to be a problem as common today as it was in the England of Tom Jones, and it is never possible to police all the game reserves that have been established.

As habitat reduction affects pheasant populations, the remaining predatory species also find their usual food supply shrinking, which prompts more intense hunting, and more danger to the often brightly colored pheasants. It is now estimated that more than half of all pheasant species are vulnerable or endangered, and that half of those are critically endangered in the wild. Some are already close to being extinct as wild birds, the Edward's Pheasant for example.

Blyth's Tragopan

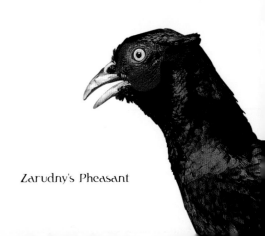

Zarudny's Pheasant

The Edward's is not one of the more spectacular types, and so was probably not much affected by the vogue early in the twentieth century for exotic feathers to decorate hats. The slaughter in Nepal and Hunan in particular was enormous. Fortunately, fashions have changed.

In some cases, the salvation of many endangered birds lies in the worldwide efforts of aviculturists, who not only have bred these rare creatures successfully, but have done so in widely separated geographical areas, so that local tragedies—wars, infections, seasonal acts of God—will not eliminate a species.

Ironically, the well-intentioned restrictions imposed by the Convention on International Trade in Endangered Species (CITES) has often made it hard for breeders to acquire new stock to diversify the gene pool. At one point the aviculture lobby had to deal with the opposition of the People for Ethical Treatment of Animals (PETA), who were initially under the mistaken impression that rare birds were being bred so that they could be released and hunted. PETA later learned the facts, and restrictions were recently relaxed.

There have been some efforts to reintroduce a few species into their former ranges. The Mikado Pheasant has been the subject of such a program, and Cheer Pheasants were released in Pakistan's Margalla Hills National Park, which is part of their former range. Fifty Cheer eggs from various European aviculturists were actually hatched in the park, and the release program was overseen by an expert in releasing captive-bred Ringnecks on shooting preserves.

Emerald Pied Spalding Peafowl

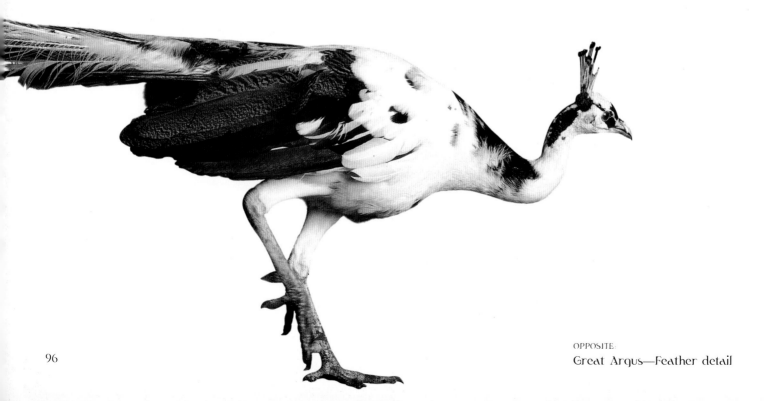

96

OPPOSITE:
Great Argus—Feather detail

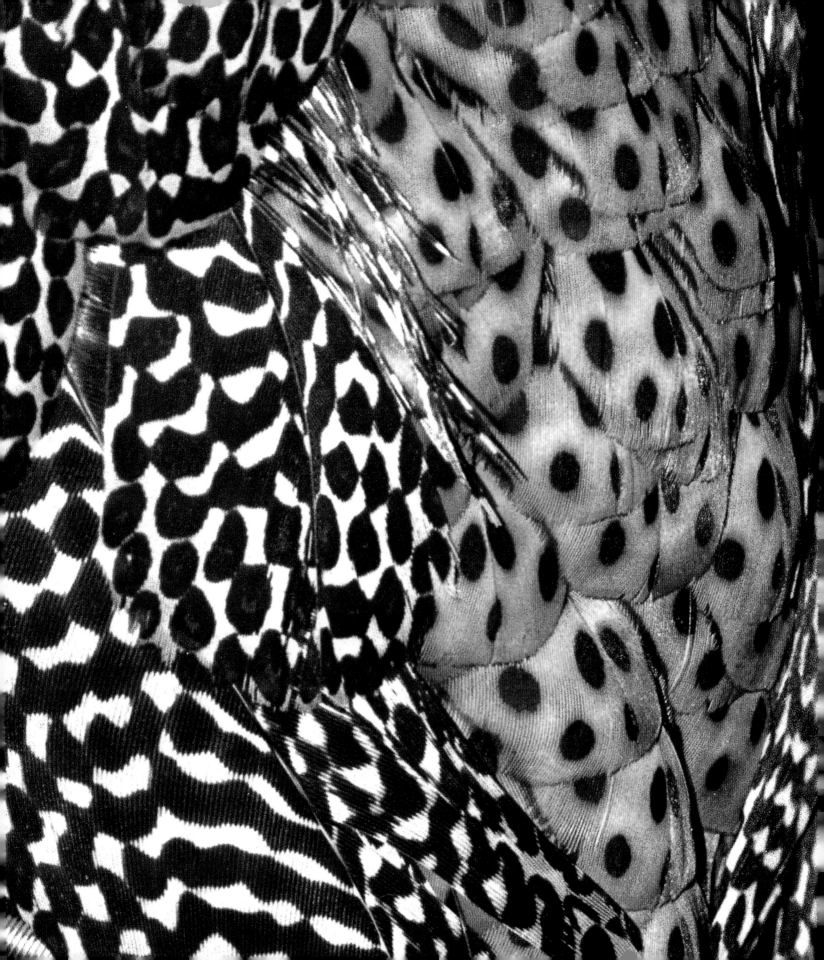

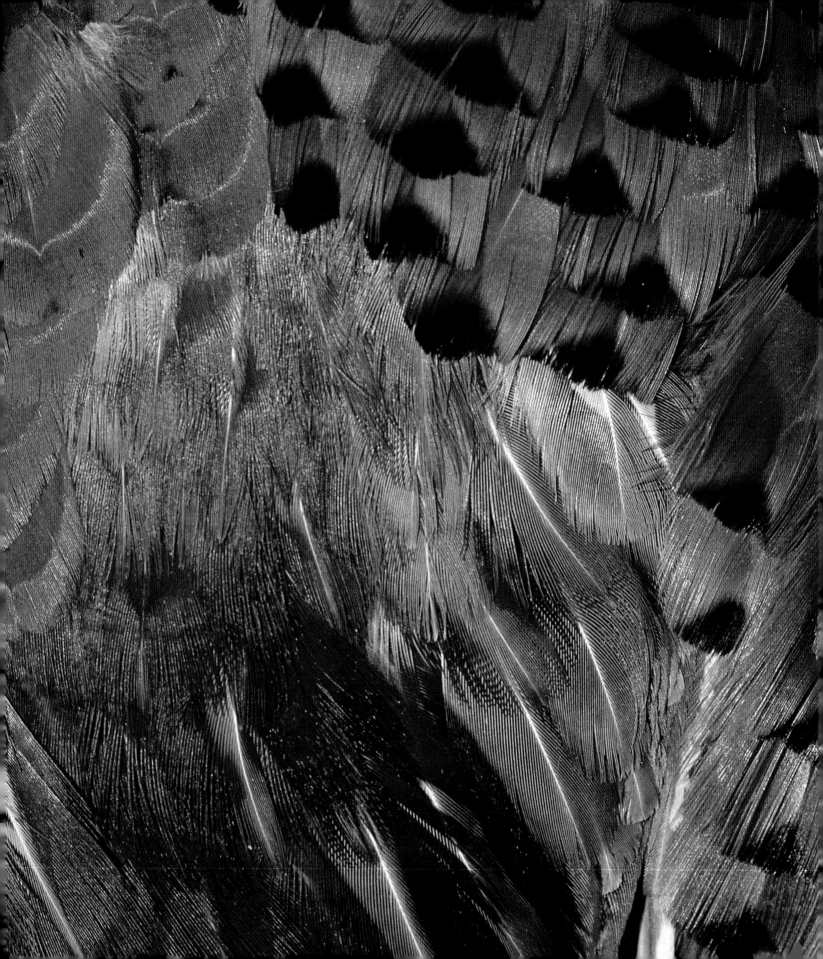

Notes on Pheasant Species

The descriptions here represent only the birds or feathers that appear in this book. They have been organized first according to genus, and within each genus by species, subspecies, and mutations. Numbers following the headings refer to illustration page numbers.

Tragopans 4, 5, 10, 14–17, 44, 95

The term *tragopan* comes from the Greek word for goat combined with the name of Pan, the horned Greek god of the fields and forests who was sometimes depicted with the legs of a goat. The birds have also been referred to as Horned Pheasants, though the horns of the Tragopan are actually of skin rather than bone, and most of the time lie flat behind the head, inflating only as part of an elaborate performance put on by the male birds when displaying to a potential mate. This display can involve circling the hen, rushing at her, and sometimes popping out from a hiding place, as well as fluffing the feathers, shuddering, partially spreading the wings, or tilting the body and wings for a lateral display. In addition to inflating the "horns," the males inflate a large colorfully patterned bib or throat wattle, sometimes referred to as a lappet.

Tragopans live at high altitudes, at least 3,000 feet above sea level. Their sturdy short-tailed bodies are well suited to trees and rough landscapes, and indeed they prefer rough terrain, with plenty of undergrowth. Unlike other pheasants, they nest in trees and spend much of their time there. This may be to reduce the risk of predation, and it also saves the nests from floods. Their speckled or blotched eggs are fairly large, producing well-developed chicks that are able to cope with their early tree-based life.

BLYTH'S TRAGOPAN 10, 16, 95
Named after the curator of the Calcutta Museum, Edward Blyth, these rare birds like rough terrain and high ground, above 6,000 feet. They are native to Assam and Burma (now Myanmar). An even rarer subspecies is the Molesworth's Tragopan, whose Latin name sounds mildly comic—*Tragopan blythi molesworthi.*

CABOT'S TRAGOPAN 4, 17
This species is particularly comfortable on tree branches. In the wild it can be found farther east, in the mountains of eastern China, and at lower altitudes than other tragopans. Dr. Cabot of Boston owned one of the first specimens known to science. An alternative name is the Yellow-Bellied Tragopan.

SATYR TRAGOPAN 5, 15, 44, left
This species also derives its name from Greek mythology—in this case horned creatures of the forests. They have also been called the Sikkim Horned Pheasant or the Crimson Tragopan. Omnivorous and solitary, Satyrs are found in a narrow range in the Himalayas, at altitudes of 7,000 to 11,000 feet.

TEMMINCK'S TRAGOPAN 14, 15, jacket back
Named after a Dutch ornithologist, this species is fairly widely distributed in China and Tibet. Before Westerners knew of the birds, however, some thought that early Chinese illustrations of them depicted a fictitious creature. Sometimes kept as pets and considered to be sources of good luck, Temminck's Tragopans show a preference for hardwood forests over coniferous. Like other tragopans, they thrive in rugged country with thick undergrowth and cool temperatures.

Koklass Pheasant 4, 18, left

In addition to the Common Koklass pictured here, William Beebe recognized two species and ten subspecies of Koklass. They can be found in mountainous country, from altitudes of about 4,000 feet up to the limit of the tree line, and ranging from Afghanistan across the Himalayas and into China and Manchuria. At those altitudes they escape humidity; they are liable not to survive if kept in a damp climate. Koklass are not gregarious, preferring to be alone or in pairs. Like most pheasants, they nest on the ground and roost for the night on tree branches.

Cheer Pheasant 4, 19, left

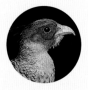

The Cheer is a genus unto itself. Although it might look similar to the long-tailed species, it is distinguished by three different characteristics—a crest, shorter legs, and a close similarity between the sexes. The male is slightly larger than the hen, but the colors and patterns are the same. Thus both male and female birds are well camouflaged when on the ground, and they usually sleep there. Hiding in long grass is a first resort to avoid predators, but the Cheer is an exceptionally fast flyer, particularly downhill, with wings closed like a swooping falcon. The bird occupies a narrow range in the Western and Central Himalayas, and attempts have been made to reintroduce the species in Pakistan. Release of captive birds in Europe was unsuccessful in establishing the species there. The Cheer may have been named for the sound it makes, which Beebe transcribed as "chir apir" and "chir chirwa."

Monals 2–3, 4, 20–23, 44

CHINESE MONAL 4, 20, 21, 44

Known as the Hoa-t'an che in China, the Chinese Monal is considerably larger than its cousin the Impeyan. It is also very rare, and very few exist in captivity. At the time of this writing, Dave Rimlinger was negotiating with Chinese scientists for a hen to replace the late mate of the solitary Chinese Monal cock at the San Diego Zoo, currently the only representative of its species in the United States. Professor Johnsgard notes that, because they use habitats similar to those of the Giant Panda, Monals are benefiting from efforts to protect that animal. The birds can be found in the Szechuan Province on high meadows above the tree line, at elevations up to 16,000 feet; they come down to the trees for roosting. Nests are often in well-protected crevices.

IMPEYAN 2–3, 22, 23, below left, jacket back

Also called the Himalayan Monal, this is the national bird of Nepal. The Impeyan's stocky build, strong legs, wide stance, and short tail are well suited to the rough, rocky terrain that is its habitat. Impeyans' conspicuous plumage makes them vulnerable to eagles, but their eyesight is excellent and they scan the skies frequently. Understandably the colorful males are more wary than the females, and they stay away from farms and villages. Impeyans prefer to forage in groups, using their strong beaks to dig large holes in search of roots, bulbs, and grubs. Their mating displays involve various movements and positions of body and wings, and their distinctive crests vibrate seductively on the tops of their heads. In addition to roosting in trees, they sometimes choose cliff sites.

Jungle Fowl 5, 11, 24–27

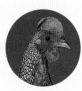

As the name suggests, these pheasants live in jungles, at considerably lower altitudes than the Tragopans or Monals. Although their origins are tropical, they have adapted to more temperate climates as well. Jungle Fowl are not closely related to other pheasant species. Their combs, wattles, and tail feathers clearly resemble those of domestic fowl, and in fact the domestic chicken is descended from the Red Jungle Fowl.

CEYLON JUNGLE FOWL 27

The climate in its native Sri Lanka permits year-round breeding, and the birds seem to adapt well to different terrains. Their preference is for partially open ground for feeding and denser vegetation for nesting and roosting. When Nilloo berries are plentiful, birds can become temporarily obese, limiting their ability to escape predators. Some observers suspect that the berries make the birds inebriated. Also called Lafayette's Jungle Fowl, this species is prone to fighting.

GREEN JUNGLE FOWL 5, 11, 24, 26–27

Native to Java and other Indonesian islands, Green Jungle Fowl thrive in their warm coastal climate. The bird makes a particularly loud noise, and, although it is not an attractive sound, Javans take pride in its volume and sponsor crowing contests. Hybrids of Green Jungle Fowl and domestic fowl are put in cages that are hoisted high in the air so that the crowing can carry long distances.

GREY JUNGLE FOWL 24, 100 right

Also called Sonnerat's Jungle Fowl, this species from Southern India is less gregarious than the Red, except when there is an area of locally abundant food. The rather stiff hackle feathers of the roosters are a popular item for fly fishermen who tie their own lures.

RED JUNGLE FOWL 25

Like their domestic descendants, these birds tend to be gregarious. Pure wild specimens can be hard to find today because, even in the areas of Southeast Asia from which they originated, Red Jungle Fowl have often mated with domestic fowl from human settlements. Today, aviculturists in the West take pride in birds that are descended from stock believed to be uncontaminated with the genes of tame creatures. Subspecies in the wild have evolved from fowl that reached other islands in the East Indies and the Pacific.

Eared Pheasants 5, 28–31, 92

These pheasants are unusual in that males and females appear almost identical. The hens are usually a bit smaller and lack spurs, but otherwise it can be hard to tell the sexes apart. Although they stay away from villages in the wild, some captive Eared Pheasants have been known to become very tame, behaving rather like pets. They make a variety of sounds, which may include a soft hooting noise or a dovelike cooing. As with the Koklass, they can tolerate cold but don't like dampness. Like many pheasant species, they usually escape danger by first running uphill, and then, if necessary, taking flight and using gravity to increase their speed by flying fast back downhill. Their interesting tail feathers once made popular decorations for ladies' hats, but the birds can be grateful that fashions change.

BLUE EARED PHEASANT 5, 30–31

In French-speaking countries, this bird is called Hoki Bleu, and in China, Maki or Machee. It has also been referred to as the Mongolian Eared Pheasant. It is a bird of the forests, moving about in large flocks, enjoying a mostly vegetarian diet supplemented by insects. In 1929, several Blue Eared Pheasants were shipped from Shanghai to Europe for breeding. Most turned out to be male birds, but those that went to Jean Delacour in France and to Pro-

fessor A. Ghigi in Italy became the beginning of successful breeding programs. The Blues have been among the creatures that have benefited particularly from the sanctuaries set up for Giant Panda preservation.

BROWN EARED PHEASANT 28, left

Sometimes called the Manchurian Eared Pheasant or, in China and some other countries, the Hoki, the Brown Eared Pheasant lives in the extreme east of Manchuria and China, where it is isolated from other eared varieties. In spite of being satisfied with mountain habitats of somewhat sparse vegetation, the bird's range has been reduced to the point of making it a vulnerable species. In the 1977 edition of his book, Jean Delacour reckoned that all captive birds were descended from a single pair bred in France by a Mademoiselle de Bellonet.

WHITE EARED PHEASANT 29, 92

Living at high altitudes in Tibet and Szechwan where very little of their habitat is protected, these birds are also considered vulnerable. Fortunately, they benefit from the Buddhist respect for all life, and many become quite tame, happy to accept handouts at monasteries. Like the Monals, White Eared Pheasants are serious diggers. They often move in very large flocks, and a noise that sounds like low conversation can often be heard coming from feeding groups. Both males and females have been known to utter cries simultaneously, which is unusual.

Gallopheasants 5, 32–45, 90

Jean Delacour wrote of this group, "In a single genus [are] ten species of pheasant which resemble each other generally in build, shape and life habits." Gallopheasants are mostly smooth striding birds with long legs and arched tails. Many, both male and female, have crests. Birds living at lower, more humid altitudes tend to have dark feathers, grading to lighter-colored feathers in higher, drier habitats. Included within the genus are the Silvers and the Kalij, which Delacour grouped together as Kalij, or *Kaleege,* using the spelling then customary, and for which he listed twenty-five subspecies. These omnivorous pheasants, which also include a group called Firebacks, scratch for food with their feet rather than their beaks, and often forage in small groups. They are distributed around Asia in such a way that normally

there exist no more than two different species of Gallopheasant in the same geographical area.

EDWARD'S PHEASANT 32–33, left

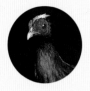

The Edward's Pheasant had the misfortune to originate in Vietnam, where years of war, and Agent Orange, have damaged their habitat. This is another bird whose habits are not well researched. Although rare in the wild, the species is fairly widely distributed in private collections.

SALVADORI'S PHEASANT 32

This is also a very rare species, both in the wild and in captivity. Little is known about its life in the forests and mountains of southern Sumatra. Some exist in nature preserves, but it is hard to police illegal timber harvesting in remote regions. Unfortunately, Salvadori's Pheasant lacks the kind of glamour that might inspire more concern.

SWINHOE'S PHEASANT 5, 32

This species native to Taiwan was named after Robert Swinhoe, a bird-loving British consul to the country when it was known as Formosa. Swinhoe's are fairly easy to raise in captivity, and attempts have been made to repopulate Taiwan with captive-bred birds. The Formosan Kalij, as it has also been called, avoids extremes of terrain—neither thick woods nor open land, neither steep hills nor flat landscapes.

CRAWFURD'S KALIJ 35, 44, left

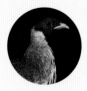

A tropical to subtropical species from the bamboo forests of southern Myanmar and western Thailand, Crawfurd's Kalij looks quite similar to the Lineated Kalij. The birds tend to be noisy and are often found near rivers and streams.

HORSFIELD'S KALIJ 34

Named after the English naturalist Dr. Thomas Horsfield, this species is sometimes referred to as the Black-Breasted Kalij. Living in northern Myanmar and in Assam and Bhutan, the birds usually travel in pairs or in small groups, but their scratching, wing-beating, and cackling sounds are easy to hear. They have been seen to act very courageously when defending their young.

LEWIS'S SILVER PHEASANT 34, 44

To quote Delacour: "We discovered this new Pheasant in December 1927, on the Bokor Plateau, Cambodia. It lives in thick evergreen forests above 2,500 feet, and is completely isolated from all other Silver Pheasants and Kalij on these southern mountains."

LINEATED KALIJ 34

These also live in the countries that used to be Burma and Siam, and Delacour also judged them to be noisy birds, making loud calling sounds throughout the year. They prefer hilly country to mountains. This species, along with the Lewis's Pheasant, looks rather like a photographic negative of the more common Silver Pheasant.

SILVER PHEASANT 36, 44

Named the Chinese Silver Kaleege by William Beebe, this bird is mentioned in Chinese literature as early as five thousand years ago. Sometimes called the True Silver to distinguish it from its thirteen subspecies, the Silver is another member of the Gallopheasant genus that moves around in noisy parties of family and friends. They are to be found in southern China, particularly the Fujian Province, though not actually on the shore itself. They can be aggressive to other pheasants, and even to humans. Nevertheless, they are popular with breeders and collectors partly because they are large and beautiful, but also because they are relatively easy to manage. The Silver Pheasant should not be confused with the Silver Golden, which will be mentioned later among the ruffed pheasants.

WHITE-CRESTED KALIJ 37, 44

Inhabiting the western Himalayan foothills, these birds live the farthest west of any other members of this genus. They like high forests with dense undergrowth, yet don't show outward concern when close to roads or human populations. These Kalij fly fast, and in areas where they are hunted they show intelligent evasive strategies. The male birds are involved with the raising of the chicks.

BORNEAN CRESTED FIREBACK 39, left

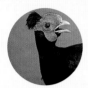

Found in many parts of Borneo, this bird is similar to the Malayan Crested Fireback. The tail feathers are a light orange, with a darker orange on the underparts, giving rise to the alternative name Orange-Bellied Fireback. There exist Greater and Lesser versions, the same in all but size. Captive birds can be pugnacious toward humans.

DELACOUR'S FIREBACK 40

This native of the southeastern part of Sumatra is similar to the Malay and Bornean Crested Firebacks. Preferring coastal regions and a warm climate, they are rarely found in captivity.

MALAY CRESTED FIREBACK 39, 90

Sometimes known as Vieillot's Fireback, this species is also to be found at lower elevations, inhabiting the Malay Peninsula and Thailand, as well as the island of Sumatra. Malay Crested Firebacks show a liking for abandoned farms and clearings and the second-growth vegetation that flourishes there.

MALAY CRESTLESS FIREBACK 40, 41, 90

There is a similar bird in Borneo, but this species is from the southern part of the Malay Peninsula, near Singapore. It was first mentioned scientifically by Sir Thomas Raffles in 1820. Sir Thomas had been governor first of Java, then of Sumatra, and had founded Singapore in 1819. Tragically, his extensive natural history collection was later lost in a fire at sea, together with all his notes and drawings.

SIAMESE FIREBACK 6, 40, jacket back

Native to Thailand, Laos, and Vietnam, the Siamese has also been called Diard's Fireback in honor of the French explorer M. Diard. Some of these birds have been domesticated in Thailand, but they have to be kept away from domestic roosters because they can easily defeat much larger birds in combat. These Firebacks have been seen to feed near cattle and water buffalo, taking advantage of insects that have been stirred up by the hooves. They inhabit low-lying land, and their diet includes small crabs. In 1862, the king of Siam presented Siamese Firebacks to the Paris Museum, marking the first appearance of this species in Europe.

BULWER'S PHEASANT 42, left

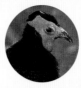

Alternatively called the Wattled or the White-Tailed Pheasant, this bird was discovered in central Borneo in 1874. Although it was initially assigned to its own genus by William Beebe, today it is grouped with the Gallopheasants. The Bulwer's habitat, like that of many other pheasants, has been shrunk by deforestation, though major replanting projects currently offer hope for its survival. The huge extension of the bright blue facial wattles, which occurs as a territorial display as well as a mating ritual, is a bizarre sight. Simultaneously, the tail, complete with more feathers than the tails of other pheasants, angles forward over the bird's back to form a beautiful circular shape.

Long-Tailed Pheasants 4, 44, 46–51, 93

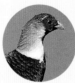

These handsome pheasants are not that different from the True Pheasants, a genus that includes the familiar Ringneck Pheasant. In fact, there have been small-scale attempts to breed some Long-Tailed Pheasants specifically for release in the wild for hunters, a practice that is ongoing for Ring-necks on a vast scale. All these birds have long, straight tails marked with a barred pattern, red wattles around their eyes, and no crest. Whereas True Pheasants have visible ear tufts, these are absent on the long-tailed species.

ELLIOT'S PHEASANT 48, 49, above

This is another species that can be violent. A dominant male may actually kill others, and there is a danger of spousal abuse. Keith Howman recommends giving the hen good hiding places in aviaries, for her protection. In eastern China, these pheasants understandably tend to be solitary or to move in very small groups. They, too, are considered vulnerable by wildlife experts.

HUME'S BAR-TAILED PHEASANT 44, 48

Small numbers of Hume's Pheasants inhabit the northeast corner of India and neighboring sections of Myanmar and Thailand. Hume himself wrote of one of the first of the species to be seen by a Westerner in 1888: "The live bird, though a full-grown cock, became perfectly tame in a few days, and a great favorite in the

camp. It would eat bread, boiled rice, winged white ants, moths, taking them gingerly out of our hands." The bird Hume wrote of had been destined for the London Zoo, but it died in a fire. It wasn't until 1961 that a Hume's Pheasant reached Britain.

IJIMA COPPER PHEASANT 44, 48, 50–51
This bird can be distinguished from other Coppers by the predominantly white feathers on its rump and lower back. The Ijima Copper is found only in the southeastern part of the Japanese island of Kyushu.

MIKADO PHEASANT 48
This species is found only in the mountains of Taiwan. It prefers cliffs and areas with steeply sloping land, terrain ill suited to lumber harvesting; thus, its habitat loss has been limited. Howman notes that the Mikado hen lays eggs that are disproportionately large to the size of the bird.

REEVES' PHEASANT 44, 46
Though these birds are now vulnerable in their native range in north central China, populations of released captive birds now exist in Britain, France, the Czech Republic, and the United States, including Hawaii. The tail feathers of the Reeves' Pheasant can grow as long as five feet. It is common for these pheasants to be particularly aggressive; even the chicks tend to fight.

SOEMMERRING'S COPPER PHEASANT 93
One must travel to Japan to see Copper Pheasants in the wild. They like hills and mountains with a mixture of forest and some open land. Their territory does not normally overlap with that of Japan's other pheasant, the Green, because the Green prefers farmland and lower elevations, though the two species may meet when Coppers move to lower feeding ground in the winter.

True Pheasants 4, 44–58, 95, 98

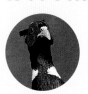

Plentiful and immensely popular as hunters' prey, these are the birds most Europeans and North Americans recognize as "pheasants." Though many of us may think of them as native species, these birds are all from Asia. Initially, Black-Necked Pheasants (*Phaisanus colchicus*)

were brought to Europe from the Near East. Later, Ringneck Pheasants (*Phaisanus torquatus*) were imported from the Far East, and these are the familiar pheasants of the North American landscape that continue to be bred in great numbers for release into the wild. In Asia there exist many subtle variations among species spread over a range that stretches from the Black Sea to the Sea of Japan, staying north of the Himalayas. Eighty years ago, Beebe sought to identify them all but found it was a daunting task: "At least thirty-five forms of these Pheasants have been described and ranked and re-ranked according to the personal bias of various authors." For example, Beebe's book describes eight different Ringneck varieties, namely, Mongolian, Manchurian, Chinese, East Chinese, Kobdo, Satchu, Korean, and Formosan. The same subtlety of differences is true among the many subspecies that are found farther west, from northern Iran and the Caucasus across the various countries that formed the southern part of the former Soviet Union. True Pheasants have no crests; rather, they have visible ear tufts on either side of the head, just behind the red wattles that surround the eyes of male birds, and their long straight tails always have a barred pattern. Though the feathers of the males have a sheen, their colors blend in among those of vegetation, so that both sexes generally roost discreetly on the ground. They prefer more open land than many other pheasant species, and can be seen in light woods, on parkland, near roads, and around farms. The Common Pheasant's instinct to burst dramatically into the air and fly fast to escape danger offers a challenge to the skills and reflexes of sportsmen hunters. If alarmed, a hen pheasant on her nest will run for a few yards before taking to the air, hoping not to give away the exact location of eggs or chicks.

BLACK-NECKED PHEASANT 4, 55
It is often hard to distinguish among the many pheasant subspecies from Armenia, Georgia, Azerbaijan, and Iran, which are often referred to as Caucasus pheasants. They have hybridized in the wild and in captivity, and their hens look so similar that it is hard for even a conscientious breeder to be sure of exact identities of their progeny.

GREEN PHEASANT 45, 53
Its Latin name, *versicolor,* means "many colored," and this tastefully exotic bird is one that is instantly recognizable as a pheasant.

At one point the tip of Korea was joined to Japan, but after the island became separated from the Asian mainland, this pheasant evolved to become a distinct species; hence, it is sometimes called the Japanese Green. The Green Pheasant can sustain flight longer than many other pheasant species and has been known to cross a mile and a half of open sea to reach an offshore island. Greens stay at lower elevations than Japan's other native pheasants, the Coppers, which means they are usually near the coast. They are also often seen close to human settlements, and sometimes share food with domestic poultry when heavy snows have restricted their natural sources. Recently, the species has been introduced in Hawaii, and some breed-and-release programs exist for sport hunting, though not on the same scale as those for Common Pheasants in other countries. Supposedly, the Green Pheasant has a useful ability to sense earthquakes before they are detected by human instruments.

MELANISTIC MUTANT 52

This large and vigorous bird is a mutation, not a subspecies, and breeds true, meaning that, when it has been mated to a Common Pheasant, the offspring are "either/or," rather than some halfway color between normal and dark. Occasionally, however, melanistic specimens with some white neck feathers have occurred. The shiny green color can be seen when the light hits the feathers at a certain angle; otherwise, the birds look black at first glance. Some breeders have experimented with developing new mutations, in much the same way as they have done with ruffed pheasants and peafowl.

RINGNECK PHEASANT 57–58, 104

Also called the Ring-Necked or Common Pheasant, this bird is often a hybrid of more recently introduced species from the Far East and those that had entered Europe centuries earlier from the Near East. In the western United States, pheasants were imported directly from China, but those in the eastern states were often re-exports from Europe. Captive breed-and-release programs involving millions of birds seem to maintain a balance with the numbers of adult birds transferred from the landscape to the dinner table by hunters.

TALISCH PHEASANT 44, 54, 98

The Talisch is one of the handsome Caucasus pheasants found on the southwest shore of the Caspian Sea, in Azerbaijan and northern Iran. Though normally the necks of the Talisch have no rings, Beebe reported seeing in the bazaars of this area birds with a few white feathers on their necks, and even partial rings.

ZARUDNY'S PHEASANT 95

On the other side of the Caspian Sea, the Amu Daria River takes rain and snow melt from Afghanistan north into the Aral Sea, dividing Turkmenistan from Kazhakstan and Uzbekistan. This river valley is the home of the Zarudny, named after a Russian naturalist and collector.

Ruffed Pheasants 4, 8–9, 58–65, 93, 105

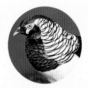

GOLDEN PHEASANT 58–59

Sometimes called the Painted Pheasant or the Red Golden, this is probably the pheasant species best known to the general public after the Ringneck Pheasant and the Peacock. It is extremely well known in China, where it is the national bird and has been featured in art and literature for centuries. It has been known to have been a captive species in the West since 1740, and is today one of the most popular choices for aviaries, both public and private.

There has been surprisingly little research on the Golden's home life in the mountains of central China. They have a preference for the kind of rough terrain that is unsuitable for agriculture, and they avoid deep forests as well as open land; swampy, boggy ground is also avoided. They move with long high strides, and are loath to fly. If alarmed, the hens find cover quickly, and the cocks will initially seek escape by running, using flight only as a last resort. Reluctance to take to the air saves them from the attention of sportsmen with guns. In addition to their startling beauty, their resilience in different climates has made them popular with breeders. Like peacocks, Goldens have been liberated on large estates as decoration, and some are now loose in the countryside. As a result, small feral

populations exist in some parts of England. There are several interesting mutations of the Golden, some of which follow.

Cinnamon Golden Pheasant 60

The name comes from the color of the hens. The mutation began with a group of five unusual Golden hens that caught the eye of William Petzold in the 1970s. Unfortunately, a raccoon broke into the birds' pen in Connecticut and killed four of them. The fifth escaped into the nearby woods but was later found and lured back into human care with offers of food. This hen became the beginning of a breeding program that resulted in the handsome Cinnamon Golden.

Dark-Throated Golden Pheasant 58

Developed in the 1860s, this is the oldest known Golden Pheasant mutation. Not only is the throat dark, but the head is also.

Ghigi Pheasant 4, 8–9, 62, 63, 93

In 1952, Professor Alessandro Ghigi of Bologna, Italy, received a yellow mutation of the Golden, crossed it with a regular Golden and spent several years cross-breeding succeeding generations to establish a bird that would breed true to this new color. Initially the birds, also called Yellow Goldens, were rare and expensive, but today they are easily obtainable at a modest price. The bright yellow of the feathers can fade to a lighter color if the birds spend much of their time in the sun.

Peach Golden Pheasant 61

The ruff, or cape, of the male bird shown on page 61 has an attractive design that includes tiny dark feathers, but pheasant expert Ralph Somes understands that dark colors should ideally be absent from this mutation, and he is familiar with specimens that feature monochrome capes. There are no hard and fast guidelines for the appearance of the Peach Golden, however, and both versions are handsome.

Salmon Golden Pheasant 60

Having established the Yellow Golden mutation, Professor Ghigi further experimented by crossing it with the Dark-Throated Golden. The result was the Salmon Golden, a bird of muted colors.

Silver Golden Pheasant 60

Not to be confused with the very different Silver Pheasant, this pale creature is a subdued mutation of the Golden Pheasant. It was developed by Marvin Everhart of Minnesota, who in the 1980s began breeding from a Yellow Golden that lacked the vivid hues of the true Golden Pheasant.

Splash Golden Pheasant 61

Splash is a term used to describe chickens, and some pheasants, whose feathers mix dark colors and white in no particular pattern. Among peafowl, however, the term *Pied* is used to indicate the presence of white feathers among the colored.

LADY AMHERST'S PHEASANT 64, 65, 105, jacket back

Living wild in eastern Tibet, northern Myanmar, and the western parts of Szechwan and Hunan, these pheasants are tolerant of cold weather. They gained their aristocratic title from a British countess whose husband was stationed in India. The birds had been a gift from Sir Archibald Campbell, who in turn had received them from the King of Ava. Sadly, the pheasants that Lord and Lady Amherst brought back to England died within two weeks of arrival. Nevertheless, current breeders and collectors have since found them hardy and easy to raise in captivity. Because the good-looking males were imported in greater quantity than the modest-looking hens, it was not unusual for the Lady Amherst cocks to be mated to Golden hens, either deliberately or accidentally. The results of these combinations were often very striking, and the cross-breeding became common. As a result, many of the captive birds of both species display traces of each other's characteristics. In an attempt to restore purity to their ruffed pheasants, some breeders today import wild specimens from the Far East and are careful to breed the Goldens separately from Lady Amherst's.

Peacock Pheasants 5, 44, 66–69, 91

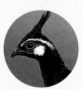

The various species of peacock pheasants are considerably smaller than actual peacocks; they are closer to the size of small chickens. The blue "eyes," or ocelli, on the tail feathers of the pheasant peacock make it is easy to understand where the species gets its name. The hens, though even smaller and with shorter tails than the males, are also spotted, though not as con-

spicuously as their partners. Just as a peacock makes a fan of its train, the peacock pheasant also presents a beautiful fan to potential mates. Whereas the peacock confronts a hen directly, however, simultaneously showing off his colorful breast, the peacock pheasant has a slightly different angle. As Charles Darwin, in *The Descent of Man*, noted, "He erects and expands his tail feathers a little obliquely, lowering the expanded wing on the same side, and raising that on the opposite side." Since spots also appear on the wings and back, this posture exposes as many of them as possible to the hen. The courting activity may also include *tidbitting*—in which the male picks up a tidbit of food and either drops it in front of the hen or seems to throw it at her. This is perhaps a modest version of the box of chocolates presented on Valentine's Day.

GERMAIN'S PEACOCK PHEASANT 69

These birds live in the humid forests of Vietnam, China, and Thailand. They take their name from a Monsieur Germain, a Frenchman who was the first to introduce the species to the West by sending a skin to the Paris Museum in 1866.

GREY PEACOCK PHEASANT 66

Locally called the Chinquis, these pheasants live in very dense jungles, near water and among rocks and ravines. As early as 1747, George Edwards described and illustrated them in *A Natural History of Birds*: "Though it be a grave coloured bird, yet it is one of the greatest beauties in nature." These are not gregarious birds, and they move through the forest alone. Their range includes the island of Hainan, between the Gulf of Tonkin and the South China Sea, though the harvesting of forest lumber has reduced that habitat. On the mainland, they live in western Assam, Bhutan, and parts of China.

MALAY PEACOCK PHEASANT 5, 44, 67, 69

Sometimes called the Crested Peacock Pheasant, this bird's crest feathers usually lie forward across the beak. Malays avoid large groups, moving alone or in pairs. Beebe was impressed by the impenetrable and hostile character of their chosen environment, declaring that "until the last mile of swamp is drained and the last valley cleared of the underbrush, this bird will exist." Unfortunately, draining and clearing today proceed at a pace Beebe could never have imagined.

PALAWAN PEACOCK PHEASANT 44, 68, 106

Alternatively called Napoleon's Peacock Pheasant, this bird inhabits the Palawan Island in the Philippines, just to the northeast of Borneo. The island is long and narrow, so that all of the birds live near the coast. Though heavy logging, particularly in the south, has reduced their numbers, some wild Palawans are protected in the St. Paul Subterranean River National Park.

ROTHSCHILD'S PEACOCK PHEASANT 44, 69

Also called Mountain Peacock Pheasants, these birds inhabit higher elevations than the Malays, over 3,000 feet above sea level, so their ranges on the Malay peninsula do not overlap. They have been observed to move in small groups. Like all peacock pheasants, Rothschild's hens lay only two eggs at a time, occasionally only one.

Great Argus 5, 44, 70–71, 97

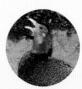

Carolus Linnaeus assigned this name to the species in 1766. It can be found on the Malay Peninsula, Sumatra, and Borneo. The Great Argus is not as large as one might think because its wing feathers extend well beyond its body. When the male is displaying, these feathers are spread out to form a fan that resembles the display of a peacock. The same round ocelli are there, but the colors are muted so that the Great Argus is less conspicuous to predators. Though their large wings make flight elegant, the birds have none of the explosive speed of many pheasant species. They tend to run from danger, and they use their powerful eyesight and sensitive hearing to minimize the need for sudden escape. The male prepares what is referred to as a dancing area, a clearing in the forest that is usually situated near a hilltop, presumably to allow his powerful call to project in all directions. The calls can be heard mostly around dusk, but also at sunrise, on cloudy days, and even on moonlit nights. The Great Argus is meticulous about keeping his dance floor neat, and some natives have exploited his instinct to pick up offending items by setting snares and traps on the ground.

Congo Peafowl 72–73, 94

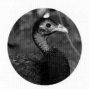

Dr. James Chapin of the American Museum of Natural History wrote: "The story of the discovery of this bird begins with a single feather, which I found on the hat of a native at Avakubi in the Ituri Forest in 1913." Twenty-three years later, Chapin chanced upon a stuffed specimen in the Congo Museum in Belgium. Fortunately, this was not like finding a mounted Dodo, and almost immediately he learned that the live birds were quite well known locally. Though naturalists agree that this is indeed a peacock, the males lack the familiar large fan of tail coverts. They are capable of a lesser display, though, sometimes in the semilateral posture seen with peacock pheasants. The Congo Peacocks make a sound that is a bit like that of the wild turkey. The only species of pheasant whose country of origin is not in Asia, the birds live in the rain forest of the Congo Basin, where they receive some protection if they are within the boundaries of the Salonga National Park in Zaire. Captive breeding programs began around 1960 at the Antwerp Zoo, Belgium, and the Rotterdam Zoo in the Netherlands.

Peafowl 5, 7, 12–13, 44, 74–89, 96

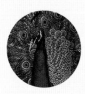

The word *peafowl* includes both males and females, though one most commonly refers to the showy male, the peacock. With some other birds, the opposite is true—for example, we refer to ducks and geese much more readily than to their male counterparts, drakes and ganders.

One of the most strikingly beautiful creatures in all of nature, the peacock has an unusual relationship with man. Most of the species we see are not caged and are allowed to roam freely, though they seem content to stay close to home and not to take off into the wilderness. Like swans, peacocks have long been used to decorate parks and the grounds of mansions and palaces. Both species are large enough to be safe from most predators. In Ranchos Palos Verdes in Southern California, a colony of peafowl has established itself among the well-landscaped private homes, causing mixed feelings among the residents. Some are charmed by the casual presence of such gorgeous birds while others complain about the noise and the mess.

Like chickens, domesticated peafowl have been around for several millennia. They reached what we now call the Middle East from India and what is now Pakistan early enough to be mentioned in the Bible (chapter 1 of the *Book of Kings*). King Solomon received them as gifts. The Phoenicians, sailing and trading out of the eastern Mediterranean, were credited with bringing them to the pharaohs of Egypt, and Alexander the Great brought them to ancient Greece, where visitors came from far and wide to see them. Aristotle, who wrote extensively on natural history, balanced local enthusiasm by observing that the huge birds could be destructive: "They are pestilent things in gardens, doing a world of mischief."

Many cultures impart religious and cultural significance to peacocks, and their image appears frequently in art. While their obvious beauty inspires thoughts of divinity, the peacocks' multiple "eyes," or ocelli, on the train have signified for some cultures the notion of threat, of "evil eyes."

Although peacocks had generally been treated with respect, and in some cases reverence, by various cultures, the Romans chose to display their wealth and mastery over the natural world by serving them roasted at banquets. Pliny wrote of a large-scale breeder who became prosperous catering to this fashion. Peacocks were later prestigious banquet fare in medieval Britain, France, and Germany, and knights were known to swear their commitment to their noble vows while carving the meat. Fortunately for the species, the eventual arrival of turkeys from the New World provided an alternate dish, equally impressive and exotic yet even more tender and more tasty than the peafowl.

In the wild their traditional enemies are leopards and tigers, and peafowl in turn have a reputation as killers of snakes. It is known that their diet can include small snakes, but it is not certain that they attack large serpents. Preferring to roost high up in tall trees, peafowl are not concerned with aerial predators, but they often choose dead trees, or ones with smooth bark, to minimize the risk of being disturbed by climbing mammals. When threatened, they can take flight very dramatically, flying almost straight up like colorful helicopters. After a night of rain, they will stay in their roosts beyond daybreak, until their feathers have lost the weight of the moisture.

Peafowl are gregarious and do not show much male-to-male aggression. Cocks tend to have small harems. Beebe was surprised to observe that perseverance is a stronger factor than beauty in winning the favors of a hen. The birds are omnivorous, like most

pheasants, mixing insects and small creatures with a variety of vegetable items. When certain fruits are in season, they may overindulge, becoming too heavy for efficient escape from predators. Although peafowl in the wild live in hot climates, imported birds seem able to withstand the winters of Europe and North America.

GREEN PEAFOWL 1, 77, 79, jacket back

Although less familiar than the Indian Blue, this species is, if possible, even more beautiful. The Green Peacock is certainly taller and more majestic, but because it is a wilder bird and not easily domesticated, it is seldom seen. Its habitats include Java, Burma, Bangladesh, the Yunnan province of China, and the countries of Indochina. The Green is divided into three subspecies—the Javan, the Burmese, and the Indo-Chinese. Linnaeus named them *Pavo muticus* under the erroneous impression they were quiet. While they certainly are not mute, they are perhaps less strident than the Indian Blues. In the wild they avoid dense vegetation, wanting an opportunity to fly from danger unobstructed. From their preferred vantage points of riverbanks and clearings, the birds constantly scan the landscape with acute eyesight.

INDIAN BLUE PEAFOWL 5, 74, 75, 81, 88, 89, 108 below

This is the peacock that is most familiar to us all. Common in zoos and on large private estates, the Indian Blue is for many people the most impressive bird they have ever seen. Although it exists as a wild species in India and Sri Lanka, and can be quite independent of the human race, even there the birds are comfortable around people. They benefit from the respect for life observed by both Hindus and Buddhists, and birds living near human settlements often became very tame. Their relationship with the populations in those countries is sometimes like that of a city pigeon in the West, or of mallard ducks on park lakes and village ponds.

Peafowl Mutations

While there is no subspecies of the Indian Blue Peafowl, there exists an increasing number of mutations. Actually, it is perhaps surprising that these creatures, which have been partially domesticated for so long, have seen very few mutations until recently. When one considers the many different breeds of dogs, cats, chickens, and cattle, it seems strange that peafowl breeding experiments were not pursued earlier. Though scientists from Darwin onward

have noted some of the variations that occurred naturally among Blues, it is only in the last few decades that serious scientific study has been undertaken. Richard Burger of Delaware kept detailed records of nearly a hundred peafowl matings and the consequent offspring. These were studied by University of Connecticut geneticist Ralph Somes, himself a pheasant breeder, and the two experts were able to identify certain patterns. While Mr. Somes's terminology—and phrases like "two phenotypes result from two mutant alleles in the same locus," or "homozygosity of an incompletely dominant gene with incomplete penetrance"—are understood by the scientific community, other breeders may have less technical knowledge. In fact, a few just wing it (no pun intended), content to wait and watch as the chicks mature.

Black-Shouldered Peafowl 44, 76, 81

According to Ralph Somes, "the black-shouldered phenotype results from a single autosomal recessive gene." Also called a Black-winged Peafowl, the bird was believed by some to be a separate species when it was first observed in 1823. Charles Darwin, however, noted the appearance of several Black-Shouldered Pheasants among a flock of regular Indian Blue Peafowl as indication of a spontaneous mutation. The two birds are distinguished by the coloring of the wing covert, which on the otherwise vividly colored Indian Blue is a neutral buff tone, mottled or barred with brown, similar to the coloring of the average hen pheasant. On the Black-Shouldered cock, however, the wing covert feathers are black, edged with blue and green.

Buford Bronze Peafowl 12–13, 85, 89

The ancestor of these peafowl was a bird, which looked rather like a Pied, that was purchased for twenty-five dollars at a swap meet in Lucasville, Ohio, the site of major poultry shows. The purchaser, Buford Abbott of Tennessee, was recognized when the mutation was named, but the bird was sold to Clifton Nicholson, who has been successfully breeding this handsome mutation in Indiana. Other breeders have subsequently been involved in establishing the Bronze.

Cameo Peafowl 85, 89

Pale hens, the potential starting point for a Cameo mutation, appeared in Italy in the 1930s but were lost during World War II. A similar hen was hatched in Florida in the 1950s but died before it

could be bred. In the late 1960s, Oscar Mulloy was finally successful in breeding from a pale hen and worked to establish the Cameo mutation, later sharing his stock with other breeders. Apparently he wanted to name the bird Silver Dunn, which is used occasionally, although the term Cameo is more usual.

Charcoal Peafowl 78
First bred at the Phoenix Zoo in Arizona, the Charcoal Peafowl is still a rare mutation. At present more male chicks have been hatched than females. The neck feathers have a surprising texture—reminiscent of the feathers of a Silkie chicken.

Oaten Peafowl 81
The Oaten is a result of breeding between Black-Shouldered Blues with Cameos; thus, it is a double mutation. Presumably we can expect to see more experiments of this sort.

Opal Peafowl 89
The Opal species began when a group of birds in a flock of Blues and Black-Shouldereds were deemed "wrong" by their owner and sold to other breeders. David Dickerson of Delaware and Dwane Jones of Maryland worked with "wrong" birds and are credited with developing the new mutation.

Purple Peafowl 80, 81, 88
This mutation occurred in an unpenned flock of mixed peafowl in 1987, when an unusual hen was bred by Jack Seipel in Arizona. The mutation was developed primarily by Clifton Nicholson's Roughwood Aviaries in Indiana, and later by other breeders.

Silver Pied Peafowl 7, 77, 89
The hens are a silver color, or rather white and gray, and the cock birds are 80 to 90 percent white. This type was bred by Dale Smith in Illinois from the mutation known as the White-Eyed, which in turn had been developed by Ernie West in California. The eye patterns in the train are without color for both types.

Blue Pied Peafowl 5, 86, 87, 88, 89
The presence of white feathers among peafowl was a spontaneous mutation, noted by Darwin and others a hundred and fifty years ago. It seems that the presence of white, or *pied,* feathering in a bird's ancestry can cause partial white feathering in later genera-

tions. More recently, breeders have been producing pied birds deliberately. The distribution and pattern of the white feathers often seems to be quite random.

White Peafowl 78, 84
These birds are not albinos, and their eyes contain pigment. It is not known how the whites developed, but they were a well-established mutation by the middle of the nineteenth century. In 1851 Darwin mentions reports by Dixon referring to White and Pied Peafowl being mixed in with a group of Blues. In spite of the lack of color, the familiar ocelli patterns can be seen in the peacock's train feathers.

Spalding Peafowl 78, 81, 88, 89, 96, jacket back
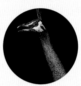
When peafowl have been mated with other members of the pheasant family, the resulting offspring have been sterile. Similar attempts to breed them with guinea fowl have also resulted in sterile offspring. Green and Blue Peafowl, however, can successfully be mated to each other. A California breeder, Mrs. Keith Spalding, is credited with being the first to stabilize this combination. The crosses can now breed true and are referred to as Spaldings. The preferred mating involves a Green hen with a Black-Shouldered Blue cock. When Spaldings are bred back to Greens, and perhaps through another generation as well, the percentage of Indian Blue blood is reduced, and the offspring are called Emerald Spaldings. If the original Indian Blue parent is already a mutation, a Blue Pied, for example, one would end up with an Emerald Pied Spalding (see above). Other well-established mutations of the Indian Blue crossed with Spaldings include the White and Cameo Peafowl, resulting in White Spalding and Cameo Spalding Peafowl, respectively.

Acknowledgments

This book would not have been possible without the generous cooperation of the many pheasant breeders who invited me to photograph their wonderful birds. But first I would like to thank the people who put me in touch with them all, E. T. and Jan Trader, officers of the American Pheasant and Waterfowl Association, and Ned Newton, a private aviculturist. In addition to their guidance on the subject of the many fine breeders in the United States, they also helped me with the photography of some of their own handsome specimens. Ned Newton was also generous with his time and his library, and personally accompanied me to three pheasants breeders in New England. At a later date, he kindly and tactfully reviewed my text.

The following are breeders who welcomed me and in most cases helped me actively with my work. For want of a better order in which to place them, I will do so in chronological order of my visits: Thomas Brenner in New Jersey; Sam and Susan Harris in Florida, with help from Scott Colomb; Elton and Patsy Housely in Alabama; Johnny Wise, also in Alabama, with help from Cindy Martin and Beverly Metcalf; Ronnie Bennett and Douglas Martin in Georgia; Don and Ann Butler in North Carolina, with help from wildlife artist Thomas Bennett; also in North Carolina, Andy and Diane Petykowski; in Massachusetts, Peter Nardi and Bill and Phyllis Parkinson; Al and Pat Novosad and Jay and Suzanne Faske in Texas; Andy Maycen in California; Manny Moreira in Massachusetts; Kurt Landig in Ohio; Dennis and Wanda Erdman and Rodney and Jill Groce in Pennsylvania.

I also visited two remarkable zoos. At the San Diego Zoo, David Rimlinger showed me the fine aviaries and introduced me to some rare species. In photographing the Chinese Monal, I was helped by Janice Owlett and Tammy Hartnet. At the Bronx Zoo in New York, Don Bruning arranged access to the Congo Peacocks, and I was assisted by Susan Leiter and Michael Williams. I also photographed from the public viewing areas at both zoos, and also at the Tracy Aviary in the heart of Salt Lake City. Some Indian Blue Peacocks were photographed at Middleton Place, Charleston, South Carolina; D'Evereux, an 1840 mansion in Natchez, Mississippi; and on the property of Richard and Peggy Fusco in Woodstock, New York.

There were other experts who gave me useful and interesting information over the phone and through correspondence: Al Cuming, Wayne Hawkins, Richard Burger, Lewis Eckhart, Ralph Somes, Louis Bougie, Allan Wautier, and Clifton Nicholson. Loyl Stromberg and Dennis Erdman sent me some helpful reference pictures at an early stage, and Andy Maycen loaned me the four wonderful volumes of William Beebe's *Monograph of the Pheasants*. I would also like to thank Abrams editor Harriet Whelchel and designer Ellen Nygaard Ford; pages of text and dozens of photographs have been miraculously transformed into a very handsome and well-organized book.

Throughout this project, I had a strong impression of a community or bird-lovers and breeding experts working hard to preserve and propagate some rare and beautiful species. In spite of being widely distributed throughout the country, aviculturists cooperate with each other, sharing knowledge and in some cases breeding stock. They do so with pride and pleasure and mutual respect, and it has been a privilege to be welcomed to their community.

Further Resources

To write these notes, I have referred primarily to four books, extracting small items of information, and I would like to acknowledge these sources, recommending them to those readers who want more than my notes, which are little more than extended captions.

William Beebe published his *Monograph of the Pheasants* in four volumes between 1918 and 1922, after eight years of preparation and with the cooperation of the New York Zoological Society. Beebe was Curator of Birds there, and in addition to studying existing material in museums and in the printed papers of other ornithologists, he spent seventeen arduous months in twenty Asian countries closely observing the wild birds and all aspects of their behavior, at one point pursuing rare and elusive specimens in the middle of a regional war. He might be considered the Indiana Jones of ornithology. Beebe's work was republished in two large volumes in 1990.

Jean Delacour, author of *The Pheasants of the World*, was a friend and admirer of William Beebe, and he also traveled to Asia a number of times for first-hand observation. He had a slightly different agenda because he was also the world's leading pheasant aviculturist. His field studies were often aimed at improving his methods of raising and breeding captive birds, and he and his agents also worked to import breeding stock, thus helping to perpetuate the genes of many species in danger of extinction. The first edition of his book appeared in 1951 and the second in 1977.

The Pheasants of the World is also the title of a more recent book, by Paul A. Johnsgard, a professor of biology and the author of more than three dozen scholarly books about birds. He approaches the subject as a scientist, drawing on research by Beebe, Delacour, and other naturalists and on research published by the World Pheasant Association. His work also addresses the subject of the endangered status of the various species. Again there have been two editions of his book, in 1984 and 1999.

Keith Howman wrote *Pheasants of the World, Their Care and Management* as a practical book aimed at breeders, and his publisher, David Hancock, has filled it with pictures, many of them by Jean Howman. Also found in Howman's book are Kenneth W. Fink's remarkable photographs of the courtship displays of Temminck's Tragopan and the Great Argus.

Anyone interested in becoming involved in or learning more about pheasant breeding can contact the World Pheasant Association—P.O. Box 5, Lower Basildon, Reading Berks, RG8 9PF, United Kingdom—with affiliate organizations in the United States, England, Australia, Canada, Taiwan, and Nepal; as well as the American Federation of Aviculture, P.O. Box 56218, Phoenix, Arizona 85079-6218; the American Pheasant and Waterfowl Society, W2270 U.S. Highway 10, Granton, Wisconsin 54436; and the United Peafowl Association, P.S. Box 24, Klingerstown, Pennsylvania 17941. Additional contacts and other information are available via the Internet.

Editor: Harriet Whelchel
Designer: Ellen Nygaard Ford

Library of Congress Cataloging-in-Publication Data

Green-Armytage, Stephen.
 Extraordinary pheasants / Stephen Green-Armytage.
 p. cm.
ISBN 0–8109–1007–1
 1. Pheasants. 2. Pheasants—Pictorial works. I. Title.
QL696.G27 G74 2002
598.6'25'0222—dc21

 2001004990

Printed in Hong Kong
Bound in China
10 9 8 7 6 5 4 3 2 1

Harry N. Abrams, Inc.
100 Fifth Avenue
New York, N.Y. 10011
www.abramsbooks.com

Abrams is a subsidiary of

LA MARTINIÈRE
G R O U P E

Binding: Great Argus—Feather detail (see also page 97)
Endsheets: Indian Blue Peacock
Page 1: Green Peacock
Pages 2–3: Impeyan—Pair
Page 88 (all Peacocks, clockwise from top left):
Blue Pied; Indian Blue; Purple; Emerald Spalding;
Cameo Spalding; Purple
Page 89 (all Peacocks, clockwise from top left):
Opal; Buford Bronze; Indian Blue; Silver Pied; Cameo;
Blue Pied; Silver Pied; Blue Pied; Emerald Spalding;
Opal; Indian Blue

PHOTOGRAPHER'S NOTES

All photographs were taken on various models of motor-
driven Nikon cameras, with Nikkor lenses ranging from
50mm to 600mm. I used the Minolta III flash meter, which
also measures ambient light, and occasionally took readings
with the Sekonic Digi Spot meter. Lighting and exposure were
usually checked on Polaroid film, Pro 100 or Type 669, either
with a 195 Land Camera or the Forscher Pro Back on the
Nikons.

 While some of the pictures were taken with available light
only, most of them were shot with flash. Whenever possible I
used Balcar heads working off DynaLite power packs. When
I needed more mobility I used the Norman 200B battery-
powered unit, or a Vivitar 285HV.

 Most photographs were taken on Kodachrome 64, but I
also used three different types of Ektachrome—SW, VS, and
200. In some cases I chose Kodak's Portra color negative films,
both the 160 and the 800. Processing was by Kodak (in New
Jersey), and Duggal, Colorite, and Fotogenic (in New York
City). Image King (New York City) made some negative-to-
chrome conversions.

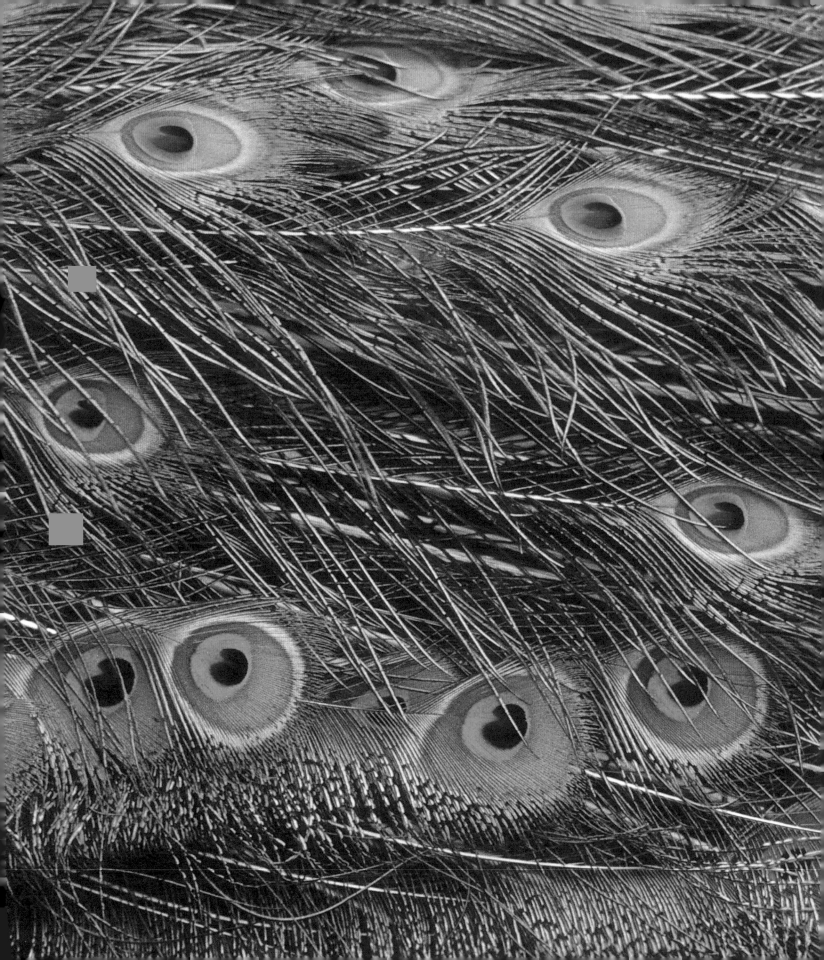